COLOUR AND LIGHT

FIFTY IMPRESSIONIST AND POST-IMPRESSIONIST
WORKS AT THE NATIONAL MUSEUM OF WALES

COLOUR AND LIGHT

FIFTY IMPRESSIONIST AND POST-IMPRESSIONIST
WORKS AT THE NATIONAL MUSEUM OF WALES

ANN SUMNER

with contributions by Louisa Briggs and Julia Carver

COLOUR AND LIGHT

Fifty Impressionist and Post-Impressionist works
at the National Museum of Wales

First published in 2005 by the National Museum of Wales,
Cathays Park, Cardiff, CF10 3NP, Wales.
© National Museum of Wales
ISBN 0 7200 0551 5
Editing and production: Mari Gordon
Design: A1 Design, Cardiff
Printing: MWL Print Group

Image details

Page 1, Claude Monet, *Palazzo Dario* (page 103)

Page 2-3, Claude Monet, *Waterlilies* (page 95)

Page 4, Paul Cézanne, *The Diver* (page 53)

Page 10, Berthe Morisot, *At Bougival* (page 107)

Page 32, Claude Monet, *Charing Cross Bridge* (page 89)

Page 34, Henri Fantin-Latour, *Larkspurs* (page 63)

Page 160, Eugène Louis Boudin, *Beach at Trouville* (page 39)

Noddir gan
Lywodraeth Cynulliad Cymru
Sponsored by
Welsh Assembly Government

Foreword

The Impressionist and Post-Impressionist paintings at the National Museum of Wales are proof that great collections are nearly always formed by remarkable individuals, rather than by institutions. The paintings, sculptures and drawings that form the subject of this book by Ann Sumner and her colleagues were bought in Paris and Britain by Gwendoline and Margaret Davies, mostly between 1912 and 1920. Additions to them, since they came to the Museum in 1952 and 1963 have, of necessity, been few. The Davies sisters deserve their reputation as pioneering collectors of Impressionism - indeed they were in many respects unique in the Britain of their day. However, our visitors find the story of these two sisters from Montgomeryshire, who throughout their lives used their great wealth largely for the benefit of others, and who seem almost to have struggled under an overwhelming sense of social responsibility, nearly as enthralling as the paintings they eventually bequeathed to us.

The debt owed to the sisters by the National Museum of Wales is immense. Their collection was at the heart of our very first loan exhibition back in 1913 - and they even quietly met the cost of organising that exhibition. They were outstandingly generous contributors to the appeal that paid for our headquarters building in Cardiff's civic centre - the collection's home today - which opened in 1922. Other loans and gifts followed, and each sister bequeathed her half of the collection on her death. The Impressionist and Post-Impressionist works discussed here are only around one-fifth of a collection that ranges from Renaissance Old Masters, through eighteenth-century British art and the French Realists (especially Millet and Daumier) to Augustus John and other more recent artists. However, its arrival here was to transform the range and ambition of the Welsh national collection.

Even before the paintings left the sisters' home at Gregynog, they were to have a profound influence on the artist Ceri Richards, and former students of the Cardiff School of Art in the 1950s and '60s still talk of the many hours they spent in front of them in our galleries. Gwendoline and Margaret Davies would have been delighted. They certainly wanted to improve Welsh art by bringing the French works they loved to Wales for emulation and inspiration. However, the sisters also believed passionately that art enriched the lives of everyone, and that it should be available to all. That belief is shared by those who care for the collection today, and it animates this book.

I am extremely grateful to Ann Sumner, and all those in the Art, Publications and Photography departments who have worked with her on this much-needed book.

Michael Houlihan

Director General, National Museum of Wales

Acknowledgements

The last book that concentrated on the French paintings at the National Museum of Wales was written by Peter Hughes and published over twenty years ago, in 1982. Although long out of print, this is still an informative tool for the study of the pictures and the few remaining copies are much treasured by curators. However, it has long been evident that a new guide to the collection was needed. Since 1982, many of the works have been loaned to exhibitions throughout the world. Much research has been carried out on them by a series of eminent scholars, giving us more information about the context in which they were produced. New works have also entered the collection, filling the art historical gaps.

I am delighted to have been given the opportunity to gather together much of the current thinking about our best known Impressionist paintings and to present them in new contexts for a wide audience. Recent publications by scholars such as John House and Belinda Thompson have influenced my writing of the general introduction. I owe a special debt to John, who inspired in me a lifelong fascination with Impressionism from my days as a student at the Courtauld Institute of Art.

Anyone writing about the Davies collection is deeply indebted to the work of John Ingamells, whose *The Davies Collection of French Art*, 1967, is an invaluable source of information. I have also benefited enormously from the work of colleagues such as my predecessor Mark Evans (Senior Curator, Victoria and Albert Museum) and our Assistant Curator (Prints and Drawings) Beth McIntyre, who have both published recently on the sisters. Important research by the independent art historian Madeleine Korn on the collecting of Impressionist paintings in Britain has also helped us to see the Davies sisters' collecting in a new light. Madeleine and other colleagues including Mark Evans, Frances Fowle, John House, Robert Meryck, Beth McIntyre, Christopher Riopelle and Anna Greutzner Robins gave papers at the 2001 conference in Bath, chaired by me, on the history of British collecting of Impressionism. A number of these papers were subsequently published in the *Journal of the History of Collections* and have proved essential reading. Some key exhibitions have also influenced our interpretation of certain works, such as Richard Bretell's *Impression, Painting Quickly in France 1860-1890* in 2001, which drew our attention to the significance of Manet's small image *Effect of Snow at Petit-Montrouge*. Other scholars have enormously informed my writing and that of my colleagues, most especially Colin Bailey's work on Renoir's *La Parisienne*, Richard Thompson and Christopher Lloyd's studies of Pissarro, Anthea Callen and Richard Kendall's work on Degas's sculpture and Mary Louise Krumrine's study of Cézanne.

I would particularly like to thank Christopher Riopelle of the National Gallery, London, who has kindly read my drafts making informed, helpful and encouraging comments, for which I am extremely grateful. My colleagues Louisa Briggs and Julia Carver have also assisted immensely, showing great enthusiasm and commitment to the project. Kate Lowry, Chief Conservation Officer, has kindly added her technical knowledge. My colleagues Richard Bevins (Geology) and David Jenkins (Industry) have both assisted in the identification of certain features in our works and the latter has also generously supplied interesting information about the Davies family. Mari Gordon in the Publications Department has offered excellent editorial advice and Samantha Wakely has painstakingly produced the bibliography and sourced illustrations. Clare Smith, Alun Jones and Kevin Thomas have kindly assisted with all necessary re-photography of our own works. As usual, Oliver Fairclough, Keeper of Art, has been a constant source of support throughout my research and writing, as has Dr Eurwyn Wiliam, Deputy Director General. This book was planned long before I took up my present post five years ago and I know it is eagerly awaited in many circles. I hope that it will raise awareness of our distinctive and distinguished collection of Impressionist paintings, shed new light on many individual works and add to our understanding of two very individual Welsh sisters whose artistic vision at the opening of the twentieth century led to a collection of such quality being held by the National Museum of Wales.

Ann Sumner

Curator (Fine Art) and Assistant Keeper, Department of Art

Contents

Impressionism: Collection and Reception

How the paintings came to Cardiff

The National Museum of Wales's collection of Impressionist paintings reflects the taste of two remarkable Welsh women, the Davies sisters: Gwendoline (1882-1951) and Margaret (1884-1963). They began forming their collection of paintings in 1908, but initially they purchased British historic works by Turner and Raeburn and works by Corot and Millet. By 1912, they had been converted to the merits of Impressionist paintings and made their first purchases of such pictures, at a time when Impressionism was not widely popular in Britain. Although there was an initial flicker of interest by collectors in the 1870s and 1890s, this was not sustained and many works subsequently left the country. There was fundamentally a general lack of appreciation of Impressionist works by public institutions. Some individuals did champion the cause, particularly the Irishman Hugh Lane between 1905 and 1915, and the English critic Frank Rutter, who tried but failed to raise funds to purchase a Monet for the state in 1905. By 1923 the Davies sisters had assembled a substantial collection of Impressionist works as well as some significant examples of French Realist and Symbolist art. In that year they moved into a large house called Gregynog in Montgomeryshire, mid-Wales, which they had acquired with its estate in 1920. Much of their collection was displayed there. The sisters pursued other areas of cultural, social and philanthropic activity at Gregynog. Music was central to their lives and a number of the paintings were hung in the Music Room. With their penchant for early Manet, late Monets (they owned nine works by the artist, although they subsequently sold one) and avant-garde appreciation of Cézanne and Van Gogh, whose works they acquired between 1918 and 1920, the sisters were remarkable pioneers in the history of British taste for Impressionism. They loaned generously to exhibitions in Cardiff, Swansea and Bath and, most significantly, in London. Although it is not clear exactly when they made the decision to leave their works to the Welsh nation, they were certainly considering the matter by early 1940. Their eventual bequests in the 1950s and 1960s transformed the collection at the National Museum of Wales.

There were a small number of early supporters of Impressionism in the art world in Britain in addition to Lane and Rutter, including the critic Sir Frederick Wedmore (1844-1921). He also influenced the development of the Welsh collection. Buying at the same time as the Davies sisters, but with fewer funds, he was acquiring directly for the Cardiff Museum and Art Gallery, whose collections were transferred to the National Museum

Sir Frederick Wedmore (1844-1921)

in 1912. The funds came from a bequest by his friend Pyke Thompson. Wedmore made some interesting acquisitions, which would eventually complement the Davies Impressionist pictures, such as Isabey, Boudin and Lepine, all precursors of Impressionism.

What was Impressionism?

Today it is difficult to imagine just how revolutionary and innovative the young artists working loosely together in the Les Batignolles area of Paris in the late 1860s were. Among them were Renoir, Monet, Sisley, Pissarro and Berthe Morisot, all future Impressionists who are now household names and whose style is instantly recognisable. They were inspired by the older artist Edouard Manet, although he did not teach any of them directly. Manet's style involved painting in broad shapes, capturing the general impression rather than minute details, and he often used a light-toned

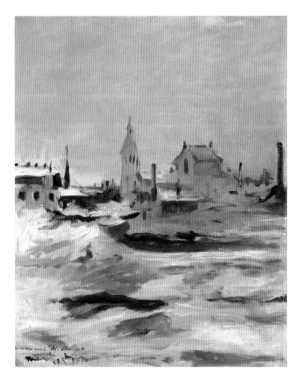

Edouard Manet (1832-1883), *Effect of Snow at Petit-Montrouge* 1870
Oil on canvas, National Museums & Galleries of Wales, Cardiff

palette of bright, unmixed colours. Influenced by Venetian and Spanish art, he admired the fluidity of the brushwork of the great Dutch painter Frans Hals. Working together, this group of young artists experimented with ways in which to analyse the effects of light and capture spontaneity and new subjects on canvas, unhindered by the restrictions or theory of the French Academy. Impressionism resulted in the discarding of some of the traditional, painstaking approaches to art that were widely taught, and emphasised instead lively brushwork and colour, producing a new freshness.

A number of these artists had experienced rejection by the official French *Salon*, the large annual state-run exhibition held in Paris each year. The exhibiting artists tended to produce formulaic compositions with neat and glossy brushwork and repetitious subjects, which were not always seen to best advantage due to an alphabetical hanging system. Although the idea of exhibiting together independently of the *Salon* was mooted by the future Impressionists in the late 1860s, the advent of the Franco-Prussian War in 1870 put the proposal on hold.

The war, though short, was bloody and resulted in humiliating defeat for France. It significantly affected each of the artists in a variety of ways, but resulted in Manet producing what is generally considered his first truly Impressionist painting, *Effect of Snow at Petit-Montrouge*, painted in one sitting while he was serving in the National Guard and defending Paris from the Prussian siege. France eventually capitulated to Prussian dominance in January 1871, when peace terms were signed at Versailles. This was followed by a brief period of civil war and the bloody suppression of the Commune in Paris, from which emerged the government of the Third Republic. The *faux* liberalism

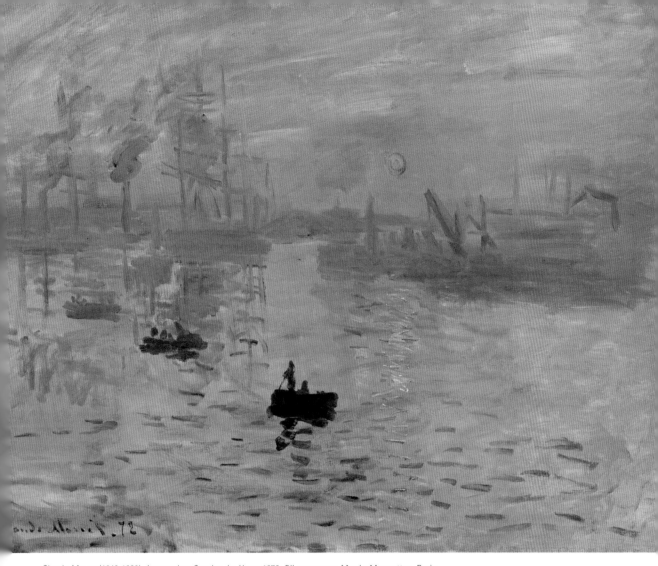

Claude Monet (1840-1926), *Impression: Sunrise, Le Havre* 1873, Oil on canvas, Musée Marmottan, Paris

of Napoleon III was now replaced by a new regime that was repressive both politically and aesthetically. The *Salon* reflected this shift in emphasis, making it an even more unlikely vehicle for the exposure of the group's new style of painting. Organising independent exhibitions became vital for artists who did not conform to conventional taste.

Despite the trauma and misery of war, France recovered extraordinarily swiftly; areas of Paris were completely rebuilt and trade quickly picked up. The bourgeoisie became and

remained central to cultural life and artists began to acquire a better status in society and, eventually, to gain more aesthetic freedom. The Impressionists resurrected the idea of having an independent exhibition, recognising it as an effective way of bringing their work to public attention in the new political climate. The first group show opened in April 1874. It was at this exhibition that Monet's *Impression: Sunrise, Le Havre* of 1873, (Musée Marmottan, Paris, *above*) attracted some hostile criticism, resulting in the coining of

the term 'Impressionism'. This term is sometimes interpreted as a derogatory expression. However, it is now generally accepted that the critical reception of the show, at which Renoir's *La Parisienne* was one of the principal exhibits, was not as hostile as legend suggests. Some prominent newspapers ignored the show completely, others simply announced the location and dates. Some reviews were favourable and indeed one critic, Armand Silvestre in *L'Opinion Nationale*, used the term 'impression' in a complimentary manner: 'it is an effect of impression alone that this vision seeks to discover; expression is left to adepts

Pierre-Auguste Renoir (1841-1919), *La Parisienne* 1874
Oil on canvas, National Museums & Galleries of Wales, Cardiff

of the line'. Jean Prouvaire in *Le Rappel* also used the word in a slightly different context in his somewhat mixed review. When discussing *La Parisienne*, which he evidently warmed to, he comments 'one gets the impression that this little girl is trying to look chaste'. The painting, which is today one of the best known and loved in the Museum, received only passing comment by various other critics. The term Impressionist was eventually adopted by the group in 1877 and was generally seen positively by them. The sheer diversity of the artists' style at that first Impressionist exhibition and their widely differing attitudes to their art meant that they shared no clear objectives or ideology, and future exhibitions they held together resulted in disagreements over who would or would not contribute. There were seven more Impressionist exhibitions, the last being held in 1886, with varying participation from the principal protagonists. Manet never renounced the idea of exhibiting at the *Salon*, believing that their new style should be seen by as many visitors as possible. Cézanne exhibited in only two of the Impressionist exhibitions, Renoir and Sisley were included in four, Monet in five and Degas and Morisot in seven - her *At Bougival* was displayed in the seventh exhibition of 1882 - while only Pissarro showed in all of them. None of the exhibitions was as significant as the first of 1874, which is now viewed as an immensely important art historical development. However, the initial purpose of the group showing was simply to gain exposure for a new style of painting and, principally, to make sales.

Who collected Impressionist paintings?

The Davies sisters' collecting in context

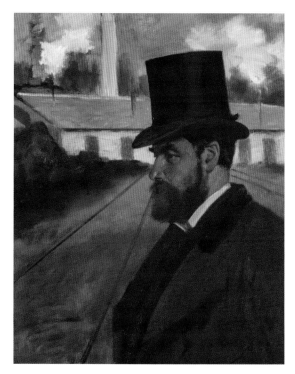

Edgar Degas (1834-1917), *Henri Rouart in Front of his Factory* c.1875, Oil on canvas, The Carnegie Museum of Art, Pittsburgh; Acquired through the Generosity of the Sarah Mellon Scaife Family

Although *La Parisienne* did not sell at the 1874 exhibition, Renoir found a buyer later that same year. The work was purchased by a fellow exhibitor and amateur artist, Stanislaus-Henri Rouart (1833-1912), a close friend of Degas who was also a successful industrialist (he was responsible for introducing refrigeration to France). Rouart paid the excellent price of 1,500 francs for the work, which entered his growing collection of art at his home on the rue de Lisbonne, where it was admired by artists and visitors for the next thirty-five years. He was a significant collector and

supporter of the Impressionists, sometimes exhibiting with them, buying their works and in 1882 sponsoring their seventh exhibition (although on that occasion he did not enter any of his own paintings). The Impressionists were indeed fortunate to have a number of loyal patrons like Rouart and later another talented artist, Gustave Caillebotte (1848-1894), who had the funds to buy their work. While Rouart's collection was dispersed on his death in 1912, resulting in the opportunity for Gwendoline Davies to purchase *La Parisienne* in 1913, Caillebotte left his superb collection to the French nation. Despite some official wrangling over many years, and some key works not being accepted, this impressive collection, which includes nineteen works by Pissarro, fourteen by Monet, ten Renoirs, nine Sisleys, seven Degas, five Cézannes and four Manets, is now in the Musée d'Orsay.

Other extremely enthusiastic, if somewhat eccentric, collectors included Victor Chocquet (1821-1891). A quiet, unassuming customs official, Chocquet inherited money from his wife's family towards the end of his life and became a patron particularly fond of Cézanne and Renoir. The latter enjoyed an especially warm relationship with the publisher George Charpentier (1846-1905) and his wife, who purchased a number of his works, commissioned portraits and actively promoted his career. Paris had a thriving art market and some dealers recognised the obvious opportunities the Impressionist style offered them. The brothers Joseph (1870-1941) and Gaston (1870-1953) Bernheim-Jeune ran a well-established gallery in Paris and with their cousin Emile also had a keen interest in Impressionism, particularly in the work of Cézanne.

The Impressionists were also fortunate to have come into contact with Paul Durand-Ruel early on. While in exile in London in 1870-71 during the Franco-Prussian War, Monet and Pissarro had met this prominent art dealer and they kept in touch with him on their return. He saw to it that Monet and Pissarro's work was included in the International Exhibition at South Kensington in 1871. Durand-Ruel kept a gallery in New Bond Street until 1875, where he showed early Impressionist work, giving the British art establishment the opportunity to appreciate and buy works from the very outset of the movement. These were held under the title Society of French Artists. British collectors

were thought to have been unimpressed and reluctant to make purchases, but it has now been shown that a number of Impressionist works did pass into British collections earlier than previously thought - Degas was particularly popular. Henry Hill of Brighton, whose family tailoring business was situated in Bond Street, had a particular penchant for Degas. He purchased his first work in 1875 and made five or six significant acquisitions from Durand-Ruel in all. The best known was *The Absinthe Drinker* (1875, Musée d'Orsay, Paris, *left*) by Degas, which he lent to an exhibition at Brighton Museum during the winter of 1876. This work was much criticised for its moral depravity.

The first significant article in English in support of Impressionism was actually written by Sir Frederick Wedmore as early as 1883 in *Fortnightly Review*. It was in this same year that Durand-Ruel organised another Impressionist exhibition at Dodeswell's Galleries in London, but the critical reception was poor. The landscapes were not appreciated, although Wedmore came to the rescue again in *The Standard*. The established art world in London was still less enthusiastic. In 1888, the artist William Powell Frith (1819-1909) attacked Impressionism, advising those artists who painted in such a manner to 'dwell longer on their impressions'. When Hill died in 1889 his paintings were the first Impressionist works to appear on the British market. *The Absinthe Drinker* was purchased by the Glasgow dealer Alexander Reid, who quickly sold it on to Arthur Kay, and by 1893 it had been acquired by the Louvre. The artist Walter Sickert (1860-1942) purchased *The Rehearsal of the Ballet* by Degas and went on to buy more examples of Degas's work from Durand-Ruel. Degas seems to have struck a chord with British artists and collectors - he was promoted by Whistler and also appealed to George Clausen (1852-1944) who had acquired a work by 1890 and to the Glasgow ship-owner Sir William Burrell whose works are now in the Burrell Collection in Glasgow, as well as to the

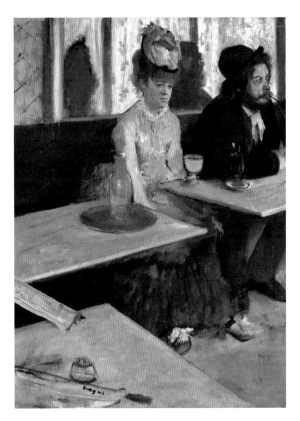

Edgar Degas (1834-1917)
In a Café, also called *The Absinthe Drinker* 1875-6
Oil on canvas, Musée d'Orsay, Paris, France

Anglo-Greek stockbroker Constantine Alexander Ionides (1833-1900) whose collection, including *The Ballet Scene from Meyerbeer's Opera 'Robert le Diable'*, was left to the Victoria and Albert Museum in 1901.

Other dealers were now beginning to exhibit Impressionist works in their London galleries, most notably Monet's individual show at the Goupil in 1889. In Scotland, Alexander Reid continued to mount exhibitions of Impressionist work, thus encouraging interest there. Clearly then, a small but sophisticated group of collectors in Britain was alert to the Impressionist style.

Quite independantly, in Germany the curator Hugo von Tschudi (1851-1911) was beginning to form the first European museum collection of Impressionist paintings from 1896 at the Berline Nationalgalerie. He was a curator of avant-garde taste compared to his contemporaries in France and Britain. In America, where so many early collections were formed, there was much direct stimulus; not so much from museum curators as from an actual artist, in the form of Mary Cassatt (1844-1926), who was also a significant collector. She was the daughter of a Pittsburgh banker and she actively encouraged her wealthy American friends to purchase Impressionist art and also helped the dealer Durand-Ruel. She wrote in her later years that it had been 'one of the chief pleasures of my life to help fine things across the Atlantic'.

The relationship between the Impressionists and Durand-Ruel was enduring; Monet, Renoir, Pissarro and Sisley all benefited from individual shows organised by him. Durand-Ruel was actively involved in promoting the Impressionists in America, with his first exhibition devoted to their work being shown in New York in 1886. America did not have French and British academic traditions that might object in the same way to the Impressionist style. In 1888, while Frith was damning Impressionism, the French critic Théodore

Duret visited America and later noted the enthusiasm for the style amongst a few key collectors, and that 'America is free from the prejudices of the Old World; the atmosphere is favourable to novelties'. In America, then, a much larger, loyal band of supporters quickly emerged, many being wealthy women collectors.

Pierre-Auguste Renoir (1841-1919), *Portrait of Paul Durand Ruel* 1910, Oil on canvas, Private collection

Substantial collections were being formed by Mrs Potter Palmer (1849-1918) in Chicago, Juliana Cheney Edwards (d.1917?) in Boston and, most significantly, Mrs Louisine Elder Havemeyer (1855-1929) in New York, who initially made purchases with her husband, an enormously wealthy sugar-cane magnate, advised by Mary Cassatt. Mrs Havemeyer was a major campaigner for women's suffrage.

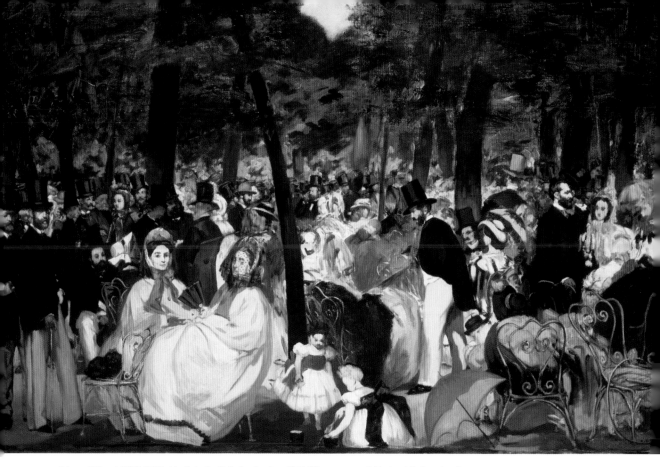

Edouard Manet (1832-1883), *Music in the Tuileries Gardens* 1862, Oil on canvas, © National Gallery, London

Her outstanding collection passed to the Metropolitan Museum of Art in New York. Duret also noted in 1910 that 'the works of Claude Monet in private collections are so numerous that it is impracticable to compile a list of them'. Durand-Ruel had indeed been truly successful in courting new enthusiasts in America, and he still had considerable influence with the Impressionists back in France. For instance, he paid for Monet's painting excursions to Rouen, Venice and London and worked closely with him in selecting some shows including the famous 1909 *Les Nymphéas: Séries de Paysages d'Eau*, in which one of the *Waterlilies* that would later come to Wales was exhibited. Furthermore, the dealer continued to do his best to promote Impressionism in Britain where enthusiasm for the style was still less than forthcoming.

In 1905, Durand-Ruel returned to the London scene and mounted his largest exhibition devoted to Impressionist paintings at the Grafton Galleries in London. This was the first large-scale show specifically devoted to this group of artists, with 315 works, but it failed to make a major impact. There were fifty-nine Renoirs, fifty-five Monets, forty-nine Pissarros, fifty-five Sisleys and thirty-five Degas with Manet, Morrisot and Cézanne represented too - the latter for the first time in Britain. Only ten works sold, suggesting that the initial enthusiasm for Impressionism had tailed off. What was significant was that one of these buyers was Hugh Lane (1875-1915), and amongst his purchases was Manet's *Music in the Tuileries Gardens* (1862, National Gallery, London, *above*), Monet's *Waterloo Bridge* (National

Gallery, London, on loan to Dublin) and *Lavacourt under Snow* (1881, National Gallery, London, *right*). Lane, who was later knighted, was the best-known collector during the early part of the twentieth century and went on to purchase *The Umbrellas* by Renoir (*page 124*) in 1907 to add to his growing distinguished collection. He was a charming Irish dealer who was well connected and worked in London but organised some influential exhibitions of 'modern' painting in Dublin and Belfast with the assistance of Durand-Ruel. Lane was appointed to the Board of Governors of the National Gallery of Ireland and was made its Director in 1914. He played a major part in setting up the Municipal Gallery of Modern Art in Dublin (now named after him). However, his relationship with Dublin Corporation was not always an easy one, and part of his highly significant collection was left to the National Gallery, London, where it was on loan (but not on display) at the time of his death as a passenger on the *Lusitania*. There was a disputed codicil to his will that would have left them to Dublin as had been his original plan. After much legal wrangling, however, the collection remained at the National Gallery, London. Today the vast majority of Lane's works are exhibited permanently at the Hugh Lane Municipal Gallery of Modern Art in Dublin and the key Impressionist paintings travel regularly between London and Dublin for display.

Private collections were growing, but it was not until Roger Fry's famous exhibition in 1910, *Manet and the Post-Impressionists*, also at the Grafton Galleries, that the movement really came to the attention of the public at large. The reaction was not entirely complimentary even then, for instance Wilfred Blunt commented that 'the exhibition is either an extremely bad joke or a swindle ... (these) are the works of idleness and impotent stupidity'. Nonetheless, the show was a turning point and Fry, along with the critic Clive Bell, continued to rise to the challenge

Claude Monet (1840-1926), *Lavacourt under Snow* 1878-81
Oil on canvas, © National Gallery, London

of converting the official British art world and collectors to the merits of Impressionism.

There were those though who needed no convincing, amongst them the Scottish animal painter Murray Urquhart (1880-1972) and his friend the critic and curator Hugh Blaker, whose sister was governess to the Davies sisters in mid-Wales. Blaker found himself in the unique position of being able to advise these young women, who had begun to collect a few years earlier. Initially he assisted with their fairly typical purchases of Turner watercolours and the like but by August 1912 he was writing to them: 'I will certainly keep my eyes open in Paris for anything good, and am delighted that you think of getting some examples of the Impressionists of 1870. Very few English collectors, except Hugh Lane, have bought them at all, although much of their best work is in America. I expect you also know the work of Sisley, Pissarro and Renoir. These can still be got quite cheaply. Sisley, whose parents were English, was as good as any in my opinion, and Degas and Daumier are desirables of course'. In that same year, the Davies sisters made their first really significant purchases by an Impressionist painter, Monet, who remained their favourite. Although Blaker

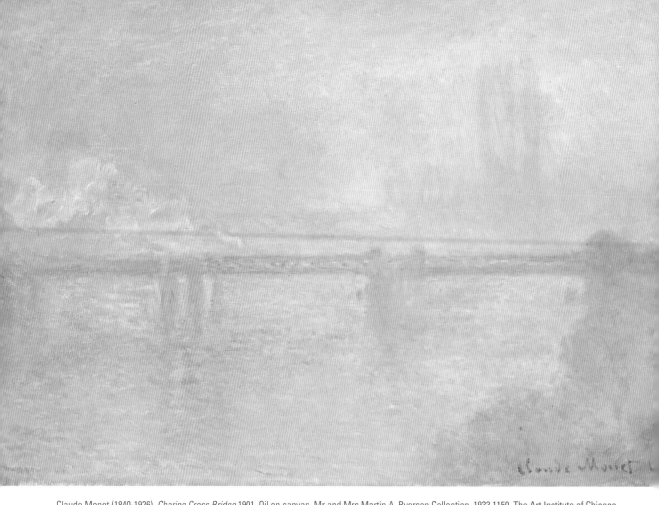

Claude Monet (1840-1926), *Charing Cross Bridge* 1901, Oil on canvas, Mr and Mrs Martin A. Ryerson Collection, 1933.1150, The Art Institute of Chicago

states that very few were collecting Impressionists in Britain, by the time they made these purchases a number of works by Degas and Monet had been acquired by British collectors, even if they had been sold on, and a smaller number of Pissarros, Manets and Sisleys had also entered British collections. It is significant though that only one painting in the Davies collection had been previously owned by a British collector – Monet's *Charing Cross Bridge (above)*, which Margaret acquired in 1913 (as *Westminster Bridge*) but which had briefly belonged to the Duke of Marlborough from 1910 to 1913. So, who were these mysterious sisters who appreciated Impressionism when so many around them did not, and where did the funds come from to make such astute and significant purchases?

A family history and the later history of the collection

David Davies (1818-1890), in the late 1880s

The Davies sisters were the granddaughters of David Davies of Llandinam (1818-1890), a self-made industrialist. Born the son of a tenant farmer at Draintewion in Montgomeryshire, the eldest of nine children, he turned to sawing to make a living and soon started to trade in timber; he went on to make a fortune through building railways, owning coal mines and building the docks in Barry. He never forgot his humble beginnings, and remained a strict Calvinistic Methodist throughout his life, a uniquely Welsh denomination quite distinct from Wesleyan Methodism. David Davies considered that Wales was 'not only the finest country in the world, but the richest' and he was certainly the richest man in Wales at the time, affectionately known as 'Top Sawyer' or 'Davies the Ocean', a reference to his Ocean Coal Company. By 1890 he employed 5,000 men in his Ton Pentre and Cwmparc pits in the Rhondda Valley. He also played a key role in the development of the new port at Barry in the 1880s, where his statue by Sir Alfred Gilbert still stands outside the Barry Docks offices. Not only was he a successful businessman but he was also a Liberal MP for Cardigan from 1874 until 1886. He was a great philanthropist who helped fund the first of the colleges of the University of Wales in Aberystwyth and supported numerous charitable causes.

His only son, Edward (1852-1898), took over the vast business interests following his father's death. A studious man with a keen interest in chemistry, he found the running of a vast business empire an unbearable strain. Edward married Margaret Jones and settled at the family home Plas Dinam in rural Montgomeryshire; but Margaret died young in 1888, leaving him with a son of eight and two young daughters aged six and four to raise. He swiftly married his wife's sister, Elizabeth, and she, with the help of the governess Jane Blaker, raised the children - David (1880-1944, later first Lord Davies), Gwendoline and Margaret. The family was brought up at Plas Dinam, with visits to their flat at Buckingham Gate, Westminster. The children were raised in the family tradition of Calvinistic Methodism. The Davies family members were prominent benefactors of the Church, although they held no official positions. The sisters were raised to attend Chapel regularly,

Gwendoline and Margaret Davies with their governess Jane Blaker, c. 1895-8

to be teetotal and strict sabbatarians. Their upbringing forbade them from dancing or attending the opera but they were allowed to play tennis and hunt and both developed a keen interest in the arts and profound social consciences. Gwendoline was an accomplished musician, playing the violin - she owned a Stradivarius - and the organ; Margaret was known for her singing voice, harp playing and her art - she painted, drew and experimented with woodcuts. Margaret also attended the Slade School of Art as an external student. Their father died in 1898 when the girls were still only 16 and 14. Neither sister enjoyed good health. Gwendoline developed an obscure blood disorder, causing lack of feeling in her finger tips and thus influencing her ability to play music. She eventually died of leukaemia.

Margaret had constant problems with her voice, often being unable to speak above a whisper. While their older brother went on to become Liberal MP for Montgomeryshire from 1906 to 1929 and parliamentary private secretary to Lloyd George before serving in the First World War, the girls enjoyed foreign travel, especially to France and Italy and even as far as Iraq, with their governess Jane. Their vast wealth, natural shyness, strict upbringing and ill-health made them very private individuals who relied on a close circle of family and school friends.

There was no established family tradition of art collecting (although their grandfather and grandmother had been painted by Ford Madox Brown) and the sisters appear to have been introduced to the concept by Jane's brother Hugh

Blaker (1873-1936). Blaker was the curator of the Holburne of Menstrie Museum in Bath, and was also an artist having trained in Paris and Antwerp. The Davies sisters' first purchase of a work of art appears to have been a watercolour, Hercules Brabazon Brabazon's *An Algerian*. By 1907, the sisters were said to be the wealthiest unmarried women in the United Kingdom and had a joint fortune estimated at £1,000,000 with an income of £40,000 a year. In 1908 the sisters purchased a pair of Turner oils and two works by Corot, following this next year with works by Millet, Anton Mauve and another Corot. They made their first major Impressionist purchases in 1912. In October, Gwendoline made a particularly advanced purchase with Manet's early oil sketch of *Effect of Snow at Petit-Montrouge*, a number of Monet's Venetian views and the full-size bronze cast of Rodin's *The Kiss*. The sisters spent over £19,000 on art purchases that year. In the following year, 1913, Gwendoline made one of the sisters' most judicious acquisitions, *La Parisienne* by Renoir, which she bought in London from the Grosvenor Gallery for £5,000.

By this time, Blaker and another of their advisers, the Scottish painter Murray Urquhart, had organised an exhibition of the collection with the somewhat mundane title *Loan Exhibition of Paintings*, under the auspices of the National Museum of Wales in Cardiff City Hall. The sisters lent thirty-eight works anonymously and some other private lenders also contributed, including Blaker, Wedmore and the infuential art dealer Joseph Duveen (1869-1939). The Davies sisters also paid all the expenses of the show including sponsoring the catalogue in which Wedmore wrote of the movement he had trumpeted for so long, 'Formerly rejected from the salons, and excluded from awards and official purchases, today their pictures are included in many of the greatest collections in the world - an appreciation which has extended to the "market" where pictures once absolutely unsaleable now command large

Hugh Blaker (1873-1936), c. 1906

sums and are eagerly sought after by collectors'.

Most importantly, the show was a success with the public, gaining over 500 visitors a day, and a series of related lectures was well attended. Blaker and Urquhart had been inspired by Hugh Lane's exhibition in 1908 in Dublin at the Municipal Gallery and Roger Fry's 1912 show at the Grafton Galleries in London. While the national press was encouraging, not everyone in Cardiff was immediately so taken by the works. The cartoonist J. M. Staniforth wrote to the south Wales paper the *Western Mail* criticising the work now seen as a significant early Impressionist picture, Manet's *Effect of Snow at Petit-Montrouge*. He felt that the Impressionist painter was one who 'endeavours to conceal by a plentitude (sic) of gaudy colours his ignorance of some

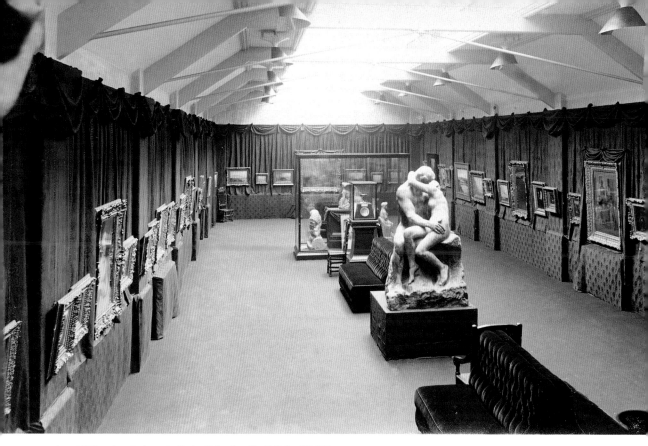

An exhibition of works from the Davies Collection, City Hall, Cardiff 1913

of the other branches of knowledge necessary to his craft' and that this particular painting 'ought never to be framed let alone exhibited'. Interestingly though, he did feel that with this exhibition there was real encouragement for the Welsh to surpass the Scots in the cultivation of the arts. Blaker was his usual enthusiastic self, describing the event as a 'stupendous show'. The exhibition went on to the Holburne in Bath owing to Blaker's connection there and *La Parisienne* was duly dispatched to join it in April 1913 immediately after it had been purchased from the Grosvenor Gallery. Thus the Cardiff and Bath showings of the Davies collection opened up new audiences for Impressionism, which previously had been seen only in London, Glasgow and Dublin.

That same year the sisters bought other major Impressionist works including Monet's *Charing Cross Bridge*, by then with the French Gallery in London and *The Palazzo Dario* acquired from the Durand-Ruel Gallery in Paris (both purchased by Margaret); the three waterlilies paintings were purchased by Gwendoline from the exhibition at the Bernheim-Jeune Gallery in Paris. Margaret also purchased Rodin's *St John the Baptist* in Paris. By the end of the year they had spent over £25,000 on art acquisitions. In 1914 they added more works by Daumier, Renoir, Mancini and Rodin to their collection but with the outbreak of World War I their collecting of French Impressionist paintings slackened for a while, as they became involved in the plight of Belgian refugee artists, who they brought to Wales to

enable them to continue their careers. Blaker's role has sometimes been over-stated, since the sisters do not always seem to have taken his advice, but he certainly was instrumental in introducing them to Impressionism and facilitating a number of their purchases.

Moved by the fate of their brother's friends and their own family members in the War, the sisters volunteered for the Red Cross and set up their own canteen at Troyes mainly for French troops, the 'Cantine des Dames Anglaises'. By this time they were in their early thirties and they found the work rewarding and liberating. Margaret moved on to work in Rouen. While in France, Gwendoline was in contact with the Parisian dealer Émile Bernheim-Jeune and made some independent choices when it came to buying works at this difficult time. In 1917 she acquired Manet's *The Hare/Rabbit*, Monet's *Rouen Cathedral: Setting Sun* and Renoir's late *Conversation*. In February 1918 however, with Paris under heavy German bombardment, she made her most ground-breaking purchases with two works by Cézanne, *Midday, L'Estaque* and *Provençal Landscape* for £3,750, again from Bernheim-Jeune. He wrote to her saying 'We repeat that we intend to help along as carefully as possible this admirable collection you are making'. The Cézannes were a progressive choice. Gwendoline was not the first in Britain to buy his art - that honour went to Sir Michael Sadler in 1911 - but Cézanne's work had not been prominently promoted in Britain at that time. The two new paintings were shipped smartly out of Paris to the safety of the Victoria Art Gallery in Bath, where they arrived just in time for a major exhibition to which the sisters were substantial lenders. There they made a huge impact, especially on the eighteen-year-old Kenneth Clark, who defied his mother's instructions not to visit the centre of Bath because of a mumps epidemic. He risked infection, taking a trip to the Victoria Art Gallery to view *Midday, L'Estaque*, (exhibited under the title *Le Barrage François Zola*,

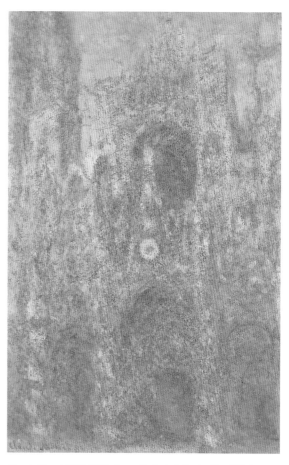

Claude Monet (1840-1926), *Rouen Cathedral: Setting Sun* 1892-4
Oil on canvas, National Museums & Galleries of Wales, Cardiff

page 45), which had a profound effect on him; Clive Bell travelled down from London especially to see the Cézannes. By November, World War I was over and the sisters returned home to a new and different country. In 1920 they added more significant paintings to their collection with the acquisition of Cézanne's *Still Life with Teapot* of around 1902 and Van Gogh's *Rain - Auvers*, another avant-garde choice by Gwendoline - both purchased from Bernheim-Jeune for about £2,000 each. Meanwhile, Margaret purchased the Rouen harbour scene by Pissarro, presumably as a memento

Gregynog Hall, Montgomeryshire, c. 1905

of her war-time experiences there. Although they also acquired Manet's *Argenteuil* at this time and a pair of Degas bronzes, their interests were shifting and they no longer had such a vast income at their disposal to spend on art, so effectively their purchasing ceased. Gwendoline wrote of her reluctance to buy works of art 'in the face of the appalling needs everywhere - Russian children ... ex-soldiers, all so terribly human - after all it is humanity that needs help and sympathy'.

The Davies sisters were by now in negotiation to buy Gregynog Hall in Montgomeryshire, not far from their family home at Plas Dinam, where the Impressionist paintings would soon adorn the walls of the music room, corridors and bedrooms. The sisters had great plans for the

house including establishing an artistic colony and giving refuge to ex-soldiers. Gradually they achieved their ambitions. Their love of music led them to establish major music festivals at Gregynog in the 1930s and to celebrate the written word in the form of poetry. Book-binding of the highest standard also took place, as illustrated in the output of the Gregynog Press from 1925 onwards. The sisters also greatly enjoyed the gardens and Gwendoline in particular sought out new plants from the Chelsea Flower Show and Royal Horticultural Hall.

They remained in contact with Blaker and wanted to share their collections with the public. In 1921 Blaker offered two of their Cézanne paintings on loan to the Tate Gallery, *Midday, L'Estaque* and *Still Life with Teapot*, but they were

refused. There followed a heated exchange of public letters, with Blaker defending the Cézannes and one of the Tate Trustees, D. S. MacColl, doubting their suitability. However, in 1922 three Cézanne paintings were included in an exhibition Roger Fry organised at the Burlington Fine Arts Club, *The French School of the last hundred years*, where they made a considerable impact. MacColl revised his opinion of *Midday, L'Estaque* and Fry wrote in the *New Statesman* that the work was 'one of the greatest of all Cézanne's landscapes'. Artistic opinion was shifting and the Tate Trustees subsequently changed their minds and accepted *Midday, L'Estaque* on long-term loan. It remained at the Tate until 1938. The inclusion of the Davies Cézannes in Fry's exhibition had a remarkable effect on a fellow collector, Samuel Courtauld (1876-1947), whose wealth came from his family textile company. He later wrote, 'I knew nothing yet of Cézanne, but I was initiated in a curious way. A young friend serving in the RFC … led me up to [*Midday, L'Estaque*] … Though genuinely moved he was not very lucid, and he finished by saying, in typical airman's language, "It makes you go this way, and that way, and then off the deep end altogether!" At that moment I felt the magic and I have felt it in Cézanne's work ever since'. Courtauld went on to amass his own inspired collection of Cézannes, now in the Courtauld Institute of Art Gallery.

The sisters continued to lend their collection, sending a number of works in 1923 to an exhibition at Agnews in Manchester entitled *Masterpieces of French Art*. The exhibition included Renoir's *La Parisienne*, which in the following year was sent on loan to the Tate until 1926. Other works went to the Tate on its return, including Cézanne's *Still Life* and Monet's *Charing Cross Bridge* and *Rouen Cathedral*. All these works remained there until 1938 when they were returned to Montgomeryshire. The sisters also lent works by Rodin to the National Museum of Wales, which were then gifted permanently in 1940. With these

exceptions, the works remained on display at Gregynog Hall where they were seen by a steady flow of visitors, from distinguished celebrities such as George Bernard Shaw, Joyce Grenfell and Stanley Baldwin, to groups associated with the sisters' charity work such as the Girl Guides, who camped regularly in the grounds. The Davies sisters had a genuine social conscience and were concerned with a wide range of charity work; they were involved in the campaign for the eradication of TB, had grave concerns over the level of unemployment in south Wales and supported the Welsh Committee of the League of Nations Union. Their brother financed the building of the Temple of Peace in Cardiff.

Both sisters were present at the inaugural meeting of the Contemporary Art Society of Wales in 1937 and served on the committee, Margaret eventually becoming Vice-President. But soon the clouds of World War II were to hang over Gregynog, and the heyday of the house in the late 1920s and 1930s was over. During the War it became a Red Cross convalescent home, although the sisters still lived there. Gwendoline and Margaret were deeply affected by the death of their brother's eldest son, who died from wounds received in battle in 1944 in the Netherlands. It was during the War years that they seem to have decided on a final bequest of their paintings to the National Museum. For a period after the War, Dutch schoolchildren were invited to visit Gregynog, but Gwendoline's health was failing and her last years were spent in a wheelchair. She died in the Radcliffe Hospital in Oxford in 1951, and her very significant acquisitions passed to the National Museum in Cardiff. During this period, while the sisters were no longer collecting major Impressionist works, others had taken up the challenge, most notably Samuel Courtauld in England and Sir Alexander and Lady Maitland in Scotland.

Margaret became more active as a collector after her sister's death, and in 1960 she decided to sell a number of works at Sotheby's in order to redirect money into buying more

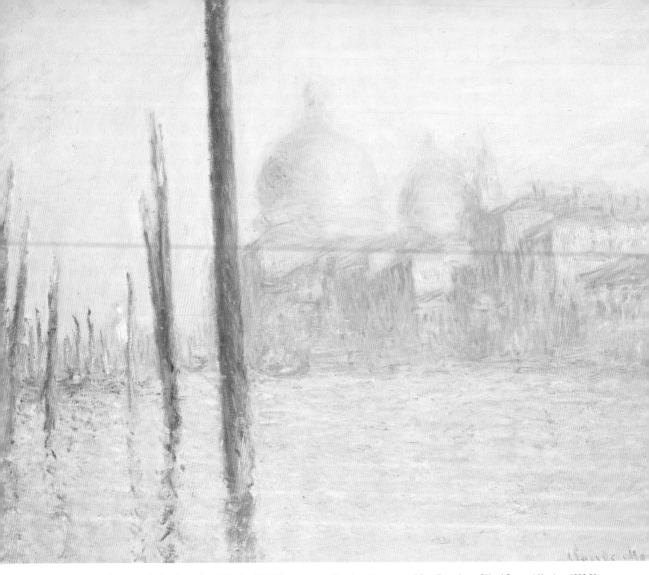

Claude Monet (1840-1926), *The Grand Canal, Venice* 1908, Oil on canvas, Fine Arts Museums of San Francisco, Gift of Osgood Hooker, 1960.29

contemporary art. These included drawings by Pissarro and Cézanne and most significantly Monet's oil painting *The Grand Canal, Venice*, 1908 (Fine Arts Museum of San Francisco, *above*). She did make one significant Impressionist purchase that year in the form of the small Sisley, an artist whom she must have felt they had neglected somewhat despite having been recommended to them by Blaker back in 1912. Whether she knew it or not, she purchased an image of Moret, the village in which Sisley had finished off his series of Welsh landscapes following his 1897 stay in Penarth and Langland Bay. Margaret also acquired works by Bonnard, Utrillo and Marquet, who had been unrepresented in the collection. She decided to stay on at Gregynog, and was now working closely with staff at the National Museum when she acquired works, recognising that she was now in the process of putting the finishing touches to a bequest that would hugely benefit a public institution. Anticipating the end of her life, in 1961 she put

the majority of the remaining paintings from Gregynog on loan. Margaret died at Gregynog in March 1963. The arrival of her part of the collection in the Museum finally transformed the collection, making it of international importance. It is this that makes the sisters' collecting of Impressionism so significant – their collection was intended for a public gallery, and for a time when Impressionism would be fully appreciated.

The Davies sisters were also unusual in terms of British collecting in that they were the only major female collectors of this style of art. They differed from their American counterparts in that they were wealthy in their own right and did not make collections jointly with male partners. They did not acquire Degas oils or pastels, which had appealed to earlier generations of British collectors. This may have been because his popularity by the time they started collecting meant that prices for his works were relatively high. Hugh Blaker's letter of August 1912 hints at the fact that one of the attractions of certain Impressionist paintings was that they could still be acquired at a relatively 'cheap' rate, which might have appealed to the sisters. It is interesting to note that their collection does not reflect one of the major themes of Impressionism: contemporary Parisian life, which of course Degas represented so perfectly. Perhaps dancing and bar scenes did not appeal to women brought up to be strictly teetotal and who were forbidden to dance. Therefore there are no examples of ballet scenes by Degas save for a single young teenage dancer in bronze, nor are there images of dancing at the Moulin de la Galette by Renoir or the Bar at the Folies-Bergères by Manet. The only image of the Parisian public at large is a distant snow scene by Pissarro of people crossing the Pont-Neuf. Paris itself also rarely occurs – Manet's early bleak image of Petit-Montrouge during the Franco-Prussian War, with no civilians or soldiers in sight, contrasts with the late Pissarro of 1902.

However, despite a strict upbringing in a remote country setting and an apparent resistance to purchasing works of modern city life, the sisters do not seem to have been prudish in their selection of art. Renoir's late nudes may not have appealed but they had no qualms about buying Rodin nudes, most notably *The Kiss* and Cézanne's *The Diver* and *Bathers*. It might have been expected that the numerous atmospheric studies of railway stations by the Impressionists would have appealed to the sisters, given the main source of their wealth, but the only work to vaguely echo an interest in their grandfather's activities is Pissarro's harbour at Rouen. This is much more likely to have been purchased by Margaret as a memento of her time there during the First World War. There are no significant portraits in the collection, although there are some impressive studies of female sitters including the young actress Henriette Henriot as the model in *La Parisienne* or the charming Julie Manet and her nanny Paisie in Morisot's *At Bougival*. Other female figures occur in Renoir's work, Pissarro's drawings of peasant women and Seguin's Breton women at prayer. There are no individual studies of male sitters except for the figure in Renoir's late *Conversation* and even here the woman dominates the scene. Landscape painting – traditionally admired in Wales – is present, most obviously in the work of Cézanne, but it does not dominate. There is a bias towards renowned architectural elements in Venice, Rouen and London. The decorative subjects of late Impressionism also appealed in the form of Monet's *Waterlilies*, of which the sisters purchased three examples and may have acquired more had not Blaker cautioned against the idea because of worries about the artist's eyesight. Their keen interest in gardening may also have resulted in their appeal for them.

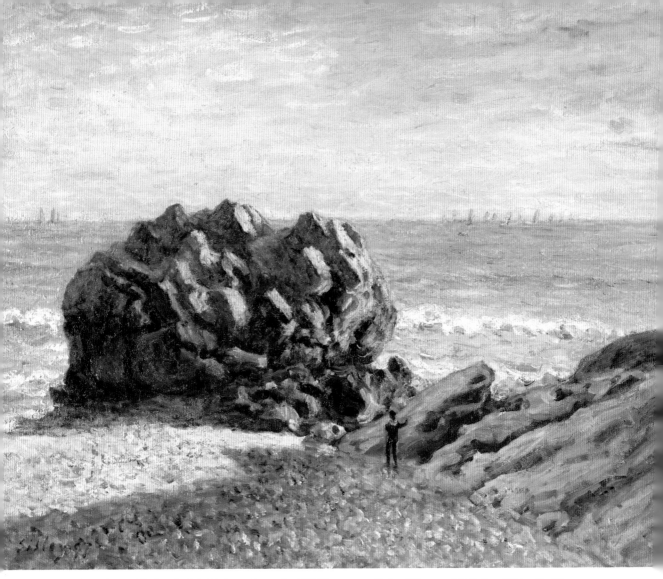

Alfred Sisley (1839-1899), *Storr Rock, Lady's Cove - the evening* 1897, Oil on canvas, National Museums & Galleries of Wales, Cardiff

The collection today

Since the sisters' bequests, the National Museum of Wales has sought to fill art historical gaps in the collection. *The Pool of London (page 83)* by Monet of 1871 was purchased in 1980 to illustrate the artist's self imposed exile in London during the Franco-Prussian War. Sisley's 1897 works *The Cliff at Penarth, evening, low tide*, purchased in 1993, and *Storr Rock, Lady's Cove - the evening*, purchased in 2004, represent the work of the only Impressionist to visit and find inspiration in south Wales. Gaps remain of course - there is no Gauguin, although the sisters thought they were bequeathing one they had purchased from a Gauguin scholar, but which is now attributed to Seguin.

Fundamentally then, despite interesting purchases by the Museum, the collection still reflects the taste of the Davies sisters and their personal choices rather than a chronological development of the Impressionist movement. It emphasises key aspects of Impressionism such as the later work of Monet and includes some major iconic images such as Renoir's *La Parisienne*. While a number of advisers clearly influenced the two sisters, most obviously Hugh Blaker, ultimately they do seem to have made significant choices themselves and it may be that their family background in Calvinistic Methodism influenced their selection of some of the subject matter. As Gwendoline wrote in 1925, 'The great joy of collecting anything is to do it yourself, with expert opinion granted, but one does like to choose for oneself. All

the time we have been collecting our pictures we have never bought one without having seen it or at least a photograph before purchase'.

The collection is recognised today as being of international importance, and works are regularly requested for loan in America and Europe. Galleries have been built and dedicated to their display. *La Parisienne* is the most popular work, and she is affectionately known by staff and visitors alike as 'The Blue Lady'. The Davies sisters would surely be proud.

The Works

Eugène Louis Boudin (1824-1898)

September Morning: Port of Fécamp

1880, signed and dated 'E. Boudin - 80' | Oil on canvas, 40.2 x 55 cm | NMW A 2427 | Purchased by the National Museum of Wales from the Goupil Gallery, London with funds from the Pyke Thompson Benefaction in 1914

Born in Normandy, the son of a ship's captain, Boudin ran a stationery and framing shop in Le Havre where he sold paintings by Isabey, Millet and Troyon before deciding to train as an artist himself. He worked *en plein air* from 1853 and generally on a small scale, taking the coastline, shipping and harbours of Normandy as his subjects. Although eventually settling in Paris, he always returned to the Channel coast during the summer months. He first painted at Fécamp, a town between Le Havre and Dieppe from 1872 to 1874, returning there in 1880 when this work was painted and continuing to find inspiration there intermittently until 1894. Typically, in this work he shows his knowledge of shipping by accurately portraying deep-sea sailing vessels, including a barque moored on the left and coastal trading vessels on the right. He painted several versions of this particular scene contrasting the slender masts of the ships with the squat silhouette of the solid church tower beyond. As well as expertly depicting the shipping, Boudin was a master of cloud painting and of water itself, particularly reflections as illustrated here.

Boudin has variously been described as a Pre-Impressionist and a precursor of Impressionism and he participated in the first Impressionist exhibition of 1874. However, Boudin's most important contribution to Impressionism was his encouragement of the young Monet, whom he first met in 1858. He is credited with encouraging Monet to paint *en plein air* in oils. Monet acknowledged the debt in 1922: 'If I have indeed become a painter, I owe it to Eugène Boudin... With infinite kindness he set about my education'. The admiration seems to have been mutual, for Boudin wrote of Monet in 1872 'I think he is destined to take one of the leading positions in our school'. Later on, both Monet and Berthe Morisot also found inspiration at Fécamp.

This work was purchased for the Museum by the perceptive art critic Sir Frederick Wedmore (1844-1921) in 1914 when he described it in a letter to the Museum's Director as 'a Boudin of, I think, unsurpassable subtlety, which is far from possible to appreciate in a moment'. Wedmore had already purchased two Boudins for the collection, showing that the Museum was acquiring French nineteenth-century *plein air* painting at the same time as the Davies sisters. Boudin was generally becoming more appreciated at the beginning of the twentieth century, as Wedmore noted later in the same letter: 'I am pleased to know that since Cardiff had its first Boudin, two have gone to the National Gallery and just lately three to the Louvre'.

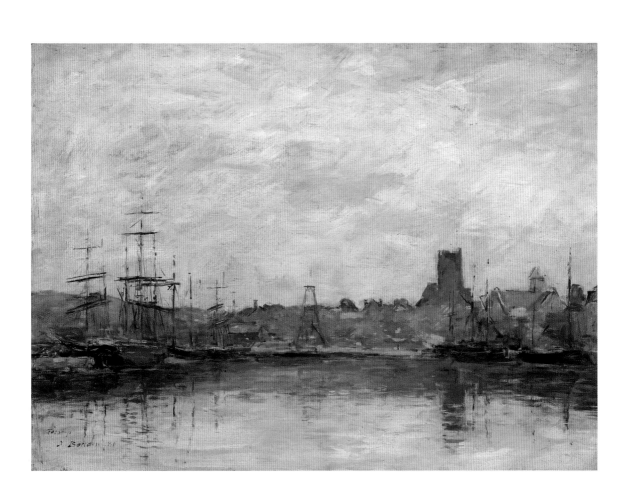

Eugène Louis Boudin (1824–1898)

Beach at Trouville

1890, signed and dated 'E. Boudin Trouville. 90' | Oil on panel, 13.9 x 26.4 cm | NMW A 2430
Purchased by Margaret Davies from the Lefèvre Gallery, London in April 1924

By the time Boudin painted this charming small work, Trouville had been a popular holiday location for fashionable Parisians and some British and American tourists for nearly sixty years. Situated at the mouth of the River Seine, this 'jewel' of the Normandy coastline boasted large hotels, a casino, wide promenades and bathing pavilions on the beach. Boudin was apparently first encouraged to paint beach scenes there by his friend and fellow artist Eugène Isabey in 1862. A native of nearby Honfleur and brought up locally, Boudin had witnessed the continual rise in visitors to the area over the years, and wrote in 1867: 'The beach at Trouville which used to be my delight, now since my return, seems like a frightful masquerade. One would have to be a genius to make something of this bunch of do-nothing poseurs... Fortunately ... The Creator has spread out everywhere his splendid and warming light, and it is less this society that we reproduce than the element which envelopes it'. Despite his personal view of these tourists, Boudin returned to the beach at Trouville over and over again for inspiration. He had begun painting polite society promenading there in 1862 and, understanding the popularity of such subjects, continued to depict them until 1896. A typical earlier view is *Beach Scene, Trouville* of *c.* 1870-74 (National Gallery, London, *right*). However, the later works are less detailed and more atmospheric in conception.

This example of his late style was executed in the year in which the dealer Durand-Ruel devoted an entire exhibition to Boudin's art in Paris. It is an impressionistic sketch with loose, free brushwork depicting ladies wearing bright colours of red, blue and yellow beside a beach pavilion. The quick brushstrokes suggest a mass of movement and colour – these figures are no longer individuals but represent invaders en masse, with the beach, so prominent in earlier works, now only partly visible. Although loose and sketchy in execution, Boudin clearly considered the painting finished, as he signed and dated it. Trouville attracted other artists such as Courbet and Monet. The latter met with Boudin there in the summer of 1870, on his honeymoon. Monet painted a series of energetic homages to his former teacher Boudin at Trouville.

Eugène Boudin (1824 -1898), *Beach Scene, Trouville* 1870-74
Oil on wood, © National Gallery, London

Eugène Louis Boudin (1824–1898)

Venice, the Molo

1895, signed and dated, 'Venice, E. Boudin 95' | Oil on canvas 36 x 58.1 cm | NMW A 2432
Purchased by Gwendoline Davies from the Durand-Ruel Gallery, Paris in October 1912

Like Monet, Boudin visited Venice late in his career. Here, from a viewpoint on the Molo, he depicts the shipping on the Giudecca, the Dogana (Customs House), Santa Maria della Salute, the mouth of the Grand Canal with its gondolas, the Giardinetti Reali and the facade of Sansovino's Zecca. Boudin's scene is taken looking south-west from a viewpoint at the water's edge outside the Prisons and next to the Ponte de la Pagio. This location was close to his lodgings on the Calle San Zaccaria and is one of the best known views in the city. The muted tones and buff-coloured sky contrast with Monet's often vivid and wide ranging palette in his paintings of Venice. Boudin first came to Venice in 1892 and was by this time already suffering from a painful nerve disease. By 1895 he was back again but was beginning to feel old and weary, 'I wish I was twenty years younger so that my stay here might be useful to me and to art, but I am tired…'. Yet, his output did not diminish. Other similar Venetian scenes are in the Musée du Quebec in Canada and The Phillips Collection in Washington. He also painted in all his usual haunts on the Normandy coast that year. This work is painted on a lightweight French canvas, primed by Boudin himself and probably taken with him to Italy. It was stretched on to a French stretcher on his return home.

The Davies sisters themselves visited Venice on a number of occasions between 1909 and 1912 with their governess Jane Blaker, and Margaret Davies kept a travel diary recording their delight in the city. Gwendoline Davies acquired this work in 1912 at the same time and from the same dealer as she purchased Monet's views of San Giorgio Maggiore (*pages 99 and 101*). When Margaret Davies purchased two small Boudins later in 1924 from the Lefèvre Galleries she was also given a letter written by Boudin in Venice on 9 June 1895 to his friend Bonjean. A quote from this seems to capture the Venice that Boudin portrayed in this work, 'it seems grey and rather dull … today a storm wraps everything with a grey, dull vapour'. He continued: 'I should like to bring back a few pictures, as faithful and honest as possible, of what interests me, but it is very difficult with our modern attitudes and our striving for atmospheric effect which takes up our time'. Thus he acknowledged the impact Impressionism had had on his painting career.

Pierre Bonnard (1867–1947)

Sunlight at Vernon

c. 1920, signed 'Bonnard', undated | oil on canvas, 47.5 x 56.2 cm | NMW A 2164
Purchased by Margaret Davies from Roland, Browse & Delbanco Gallery, London in July 1960

Born in 1867 in Fontenay-aux-Roses, a suburb of Paris, Pierre Bonnard began his career by studying law. In 1887 he changed direction when he attended the Ecole des Beaux-Arts and the Académie Julian in Paris. During this time, Bonnard met fellow artists Maurice Denis (1870-1943), Paul Sérusier (1863-1967) and Edouard Vuillard (1868-1940) with whom he later became connected in the Nabis group (*page 138*).

Although he kept a studio in Paris his entire life, Bonnard increasingly began to spend time out of the city. He first visited Vernonnet, close to Monet's home Giverny, in 1912 whereupon he purchased a small half-timbered house with a wooden balcony, which he termed 'Ma Roulotte' ('My Trailer'). Vernonnet is situated on the right bank of the Seine and Ma Roulotte had a superb view of the river, which Bonnard took full advantage of. This house was a part-time residence from which the artist worked from 1912 to 1928, producing paintings that recorded the changing effects of light on the Seine and surrounding landscape.

Sunlight at Vernon is undated by Bonnard but is thought to originate from about 1920 and shows the artist's garden at Vernonnet. The figure visible at the lower right of the work may be the artist's wife Marthe de Méligny, whom Bonnard met in 1893, after which time she became his primary model. They married in 1925. The figure is shown engaged in the private, mundane act of gardening. The garden appears vivid with lush greens and vibrant pinks of flowers. Another version of this view, *Blue Balcony* (The Samuel Courtauld Trust, Courtauld Institute of Art Gallery, London, *right*), was painted ten years earlier and has a much more sombre palette (after the First World War, Bonnard's palette became markedly brighter). In his later years, Bonnard

became increasingly fascinated by the relationship between interiors and gardens and many works exist, painted at Vernonnet, exploring this correlation.

Bonnard afforded himself only a few luxuries, one of which was a car. On its purchase in 1911, he began to travel frequently, painting in different locations and carrying canvases of unfinished works with him. His paintings were not necessarily finished in the places in which they were set, and this work may have been completed away from Vernonnet.

Previously owned by the writer J. B. Priestley, this painting is the only work by Bonnard in the Davies sisters' collection.

LB

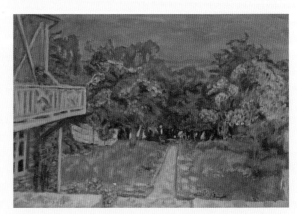

Pierre Bonnard (1867-1947), *Blue Balcony* 1910, Oil on canvas
The Samuel Courtauld Trust, Courtauld Institute of Art Gallery, London

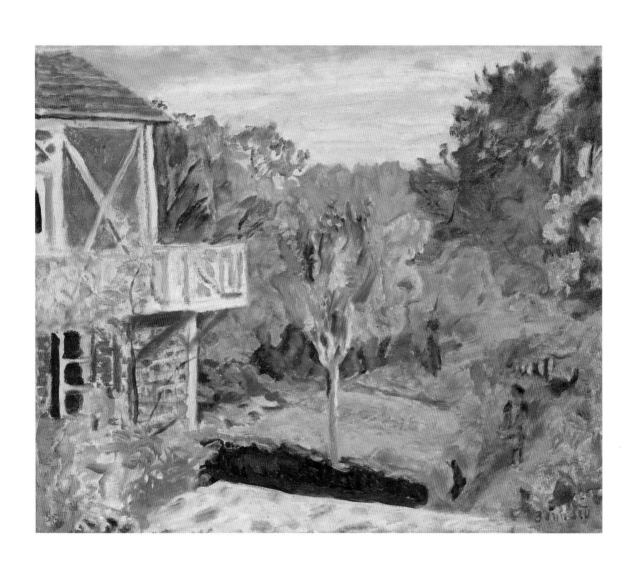

Paul Cézanne (1839–1906)

Midday, L'Estaque

c.1879, undated | Oil on canvas: 54.2 x 74 cm | NMW A 2439
Purchased by Gwendoline Davies from the Bernheim-Jeune Gallery, Paris in February 1918

This mountain landscape is one of Cézanne's most admired pictures and has a fascinating history, particularly with regard to British appreciation and collecting of the artist's work. The son of a banker from Aix-en-Provence, Cézanne was a southerner at heart, who exhibited at the first Impressionist exhibition in 1874, but from 1875 onwards spent increasing amounts of his time working in his native Provence, either at Aix or at L'Estaque, a small seaside village near Marseille. The date of this work has been debated by scholars, some proposing an early date of c. 1878-9 and others a later date of 1883. However, the first owner of the painting, Paul Gauguin, recorded it as in his possession by 1883 and took it with him to Copenhagen by 1884. The summary technique also supports the earlier date.

The painting support is a fine linen canvas with a commercially prepared white ground, subsequently covered with a cream coloured ground by the artist, hence its smooth appearance. Previously it has incorrectly been suggested that the work was painted on commercially prepared paper. Cézanne appears to have worked rapidly creating thick, unmodulated areas of paint with a saturated brush, creating simplified forms. Stylistically, the picture combines the swift approach to his watercolours with the uniform handling of his oils. The composition itself has an almost naive quality, for instance in the semi-circle of evenly spaced trees in the foreground lining the dusty road.

The precise topographical location has never been satisfactorily identified, and the picture has had numerous titles. Paul Gauguin was a wealthy stockbroker with a good collection of Impressionist paintings purchased during the 1870s and 1880s. He purchased this work from Père Tanguy, along with another Cézanne. In a letter to Pissarro of 1883

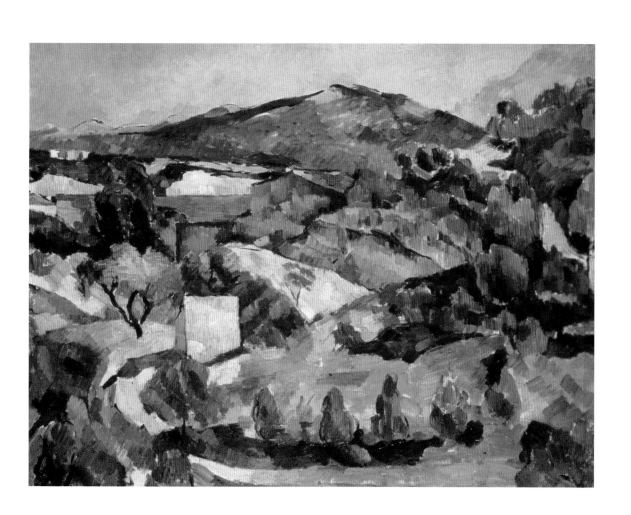

Paul Gauguin (1848-1903), *Study for a Landscape* 1885, Gouache on canvas, NY Carlsberg Glyptotek, Copenhagen

he described this painting as 'a view of the Midi that's unfinished but very advanced - blue - green and orange'. Gauguin took his collection with him to Copenhagen in 1884, when he and his Danish wife visited her family in the autumn following the crash of the *L'Union Generale* bank, which had caused him great financial distress. Despite his financial difficulties he was now determined to pursue a career as an artist. He tremendously valued this particular Cézanne and used it as a starting-point for a fan design in 1885 - *Study for a Landscape* in gouache on canvas (NY Carlsberg Glyptotek, Copenhagen, *left*). In 1889, the original Cézanne was amongst a group of works from Gauguin's collection exhibited at the Art Society in Copenhagen. By 1891 however, Gauguin had decided to travel to Tahiti and his wife Mette was forced to sell this painting for financial reasons to the Danish collector Edvard Brandes. Gauguin tried unsuccessfully to buy it back in 1894. By 1913 it had returned to France and was with Bernheim-Jeune in Paris. He sent it to his gallery in New York for an exhibition of Cézanne's work, exhibiting it under the title *The François Zola Dam*. It was well received critically, but it was not purchased and it was returned to Paris, to be acquired with *Provençal Landscape* by Gwendoline Davies in February 1918 as Paris came under German bombardment in the closing stages of the First World War. Eager to get the paintings out of war-torn France, the Davies sisters swiftly transported them back to Britain and straight on to display at the Victoria Art Gallery in Bath, where a selection of their paintings was already on show. In Bath, under the title *Le Barrage François Zola*, it was much admired by the young Kenneth Clark. However, the picture and *Still Life with Tea Pot* (*page 51*) were offered in 1921 on loan to the Tate Gallery by the Davies sisters' artistic adviser, Hugh Blaker, and initially rejected. They finally went on display at the Tate in 1922, after an angry public exchange of letters and a brief appearance at Roger Fry's Burlington Fine Arts Club exhibition of French art. It was exhibited as *Montagnes, L'Estaque* and viewed by the collector Samuel Courtauld who later commented 'At that moment, I felt the magic, and I have felt it in Cézanne's art ever since'. The next year, he acquired the first of his Cézannes. From this period onwards the general assumption has been that the picture was painted at L'Estaque. The area of blue paint representing water however is difficult to reconcile with the area of arid land looking inland from L'Estaque and the valley behind Le Tholonet. The only body of water in that area is the François Zola Dam on the slopes of Mont-Sainte-Victoire. In which case, the early titles given to the work in 1916 and 1918 when it was exhibited in New York and Bath may indeed be correct, making this Cézanne's only depiction of this site.

Paul Cézanne (1839-1906)

Provençal Landscape

c.1887-8, undated | Oil on canvas, 81.2 x 65.7 cm | NMW A 2438
Purchased by Gwendoline Davies from the Bernheim-Jeune Gallery, Paris in February 1918

Cézanne's art had a strong personal link with his home region of Provence. The region was relatively undeveloped compared to the northern landscape surrounding Paris on the river Seine and the Normandy coastline so popular with the other Impressionists. Even the railway that opened up so much of the French landscape for the Impressionists in the north was late in being established there. The Aix-Marseille line did not open until as late at 1877. The Mediterranean landscape shimmering in the heat of the sun was central to Cézanne's development of landscape painting. 'This region is full of undiscovered treasures. There has been no one to date who proved worthy (in his pictures) of the riches that lie slumbering here' he wrote to his patron Victor Chocquet in May 1886. It was in that year, on the death of his father, a hatmaker and exporter turned successful banker, that Cézanne inherited a quarter-share of his 1.6 million francs fortune. His financial worries were now over. In 1887 he was painting at Jas de Bouffan, a thirty-seven acre estate just outside Aix that his father had purchased in 1859. He visited frequently to care for his ailing mother and it is probably here, where he produced so many paintings, that he made this study of a copse of trees. The criss-crossed broken brushwork, delicate colour contrasts and balance between surface and spatial effects are typical of his output in the late 1880s. The ground of the painting is barely covered in places and the picture has a sketch-like quality.

The experience of painting in the south showed Cézanne the full potential of colour. He later wrote that one of his great discoveries was that 'sunlight cannot be reproduced, but that this must be represented by something else - by colour' and it is Cézanne's use of colour that gives this painting its appeal. The combination of colour contrasts, of the orange-brown foreground with the bluish-green foliage and purplish trunks of the trees, conveys the warm light of Provence.

Paul Cézanne (1839–1906)

Still Life with Teapot

*c.*1902–6, undated | Oil on canvas, 61.4 x 74.3 cm | NMW A 2440
Purchased by Gwendoline Davies from the Bernheim-Jeune Gallery, Paris in 1920

Cézanne began concentrating on still-life painting from 1870 onwards, perhaps inspired by the display of a great collection of still-lifes by Chardin that entered the Louvre in 1869 in the La Caze bequest. In his early still-life compositions he was undoubtedly influenced by the Spanish and Dutch painters of this genre, as well of course as by Chardin himself.

The central motif of Cézanne's still-lifes was fruit. Writing to the poet Gasquet, who he met in 1896, he said of the fruit he used, 'they come to you laden with scents, tell you of the fields they have left behind, the rain that nourished them, the dawns they have seen. When you translate the skin of a beautiful peach in opulent strokes, or the melancholy of an old apple, you sense their mutual reflections, the same mild shadows of relinquishment, the same loving sun, the same recollections of dew.' The objects in early works such as *Vessels, Fruit and Cloth* 1879–80 (Hermitage, St Petersburg) tend to be presented frontally and usually separately from each other in static groupings.

Only later during the 1880s did he develop his style of still-life painting, abandoning the frontality of his earlier works and adopting elaborate counterpoints between shapes and textures, colours and patterns. The young Louis le Bail observed Cézanne composing a still-life composition of a napkin and a glass of red wine in the late 1890s: 'The cloth was very slightly draped on the table, with innate taste. Then Cézanne arranged the fruits, contrasting the tones one against the other, making the complementaries vibrate, the greens against the reds, the yellows against the blue, tipping, turning, balancing the fruits as he wanted them to be, using coins of one or two sous for the purpose. He brought to this task the greatest care and many precautions; one guessed that it was a feast for the eye to him'. The careful assembly of motifs was only Cézanne's starting point. The visual space in his still-lifes is subject to minor inconsistencies of perspective that reflect his own proximity and relationship with the objects. Each time he moved, he modified his relationship to the group, concentrating on one object, then another. Cézanne compared painting still-life objects with painting portraits. 'People imagine a sugar bowl with no face, no soul. But it changes every day. You have to know how to get hold of these fellows... These glasses, these plates, they talk to each other, they're constantly telling confidences'. A sugar bowl features in this late work, one of a series showing fruit, vegetables and crockery on a table in his studio in Aix, painted during the last years of his life. Here peaches are arranged on a plate and on the table, while a knife, teapot and the sugar bowl are displayed against a rich elaborate cloth, carefully arranged in folds, to complement the positioning of the objects. The perspective has characteristically been manipulated, with details such as the knob of the teapot lid being suppressed to emphasise the autonomy of form over subject-matter. The foreground plate bends towards us and the table legs conflict with the table top. The colours are strong, set off by a green-grey background. Gauguin admired Cézanne's still-lifes. He owned *Fruit Bowl, Cloth, Glass and Apples* 1893–4 (Bereggruen Collection, Paris), a work which was later exhibited in Paris as part of the *Century Exhibition of French Art from David to Cézanne* at the Paris World Fair in 1900, illustrating that Cézanne's still-lifes, once only known and appreciated by a few choice collectors, were gaining a wider audience.

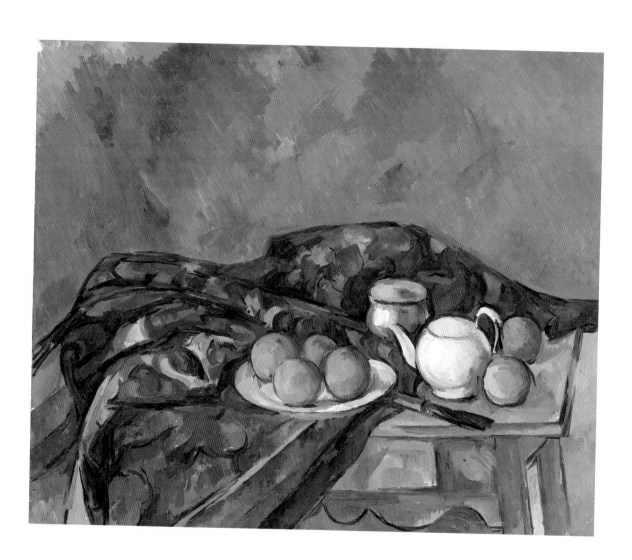

Paul Cézanne (1839–1906)

The Diver

c. 1867–70, undated | Inscribed in pencil, recto, tou… [illegible] for…x 90 | Inscribed in pencil, verso, 128…x12 large gar…
[illegible] 218…x21 larg_…[illegible] | femme piquant une tete dans l'eau | watercolour, bodycolour and pencil on paper, 15.6
x 16.2 cm | NMW A 1683 | Purchased by Gwendoline Davies from the Bernheim-Jeune Gallery, Paris in March 1920

The many *Bathers* paintings and watercolours Cézanne produced throughout his career seem to speak, among other things, of nostalgia for a mythological Golden Age of simple pleasures, or, more specifically, of days spent swimming with boyhood friends during his childhood in Aix. However, sinister undertones can be read into many of the *Bathers* compositions, and they might not be the idyllic pastorals they initially seem.

The *Bathers* pictures also remind us of Cézanne's admiration for Old Master paintings and for Poussin and Rubens. Like the Impressionists, he copied paintings in the Louvre and his female figures share the monumental stature of Rubens's women. They also contain hints both of violence and eroticism. Cézanne painted *The Diver* around the same time as his *Abduction* of 1867 (Fitzwilliam Museum, Cambridge), which shows a giant male figure carrying a limp female captive away and has been variously interpreted as representing Hercules's rescue of Alcestis from the underworld, or, conversely, Pluto carrying Persephone into his underworld. *The Diver* has been linked to a watercolour study for this work.

The sex of the diving figure in this watercolour is ambiguous: the work was described as *The Fall of Icarus* by Lionello Venturi in his catalogue raisonné, but was called *Woman Diving* when it was sold to Gwendoline Davies. The muscular form of the figure corresponds to that of men *and* women by Michelangelo, whom Cézanne also admired, and indeed to Cézanne's many other *Bathers*. The long hair, which appears to fall forward between the diver's arms, perhaps denotes a woman. A shaded contour under the arm possibly delineates a woman's breast. This bather is distinct from Cézanne's other *Bathers* in his/her activity, and the movement of the figure is echoed in the choppy texture of the water, while the hollowed-out foliage that outlines the disc of moon is reminiscent of the harmonies of Poussin's compositional method.

The technique is typical of Cézanne's early style of watercolour painting, using opaque white gouache with the transparent liquid watercolour to delineate light. Later, he would paint his watercolour onto white paper, using the white spaces left uncovered as positive elements in his painting. This watercolour is densely worked, the figure first modelled in pencil with heavy diagonal hatching highlighted with thin strokes of gouache and patches of pink, mauve and blue watercolour. Passages of pencil hatching are clearly visible in the background foliage. The composition was begun in a wider format which Cézanne had abandoned, although his original blocking-out of the composition in pencil is visible at the left margin of the work.

JC

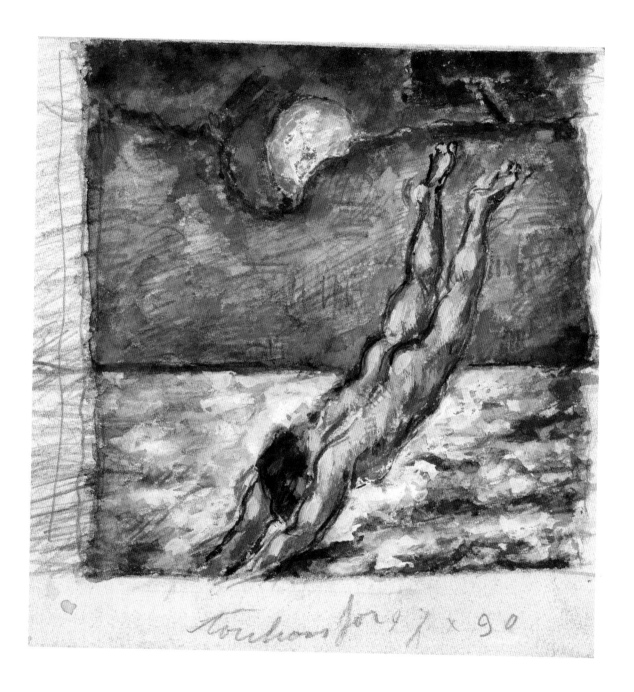

Paul Cézanne (1839–1906)

Bathers

c. 1875–77, undated | Inscribed in pencil, recto, lower left: 13 …[illegible] 11 vert toub…[illegible] | Inscribed in pencil, verso, bottom centre: Baigneuses | watercolour, bodycolour and pencil on paper, 16.3 x 15.7 cm | NMW A 1682
Purchased by Gwendoline Davies from the Bernheim-Jeune Gallery, Paris in March 1920

Cézanne was a prolific watercolourist and submitted watercolours among the sixteen works he sent to the third Impressionist Exhibition in 1877. There are known to be about four hundred in existence. The medium enabled him to be spontaneous and it seems that his watercolours freed him up in his oil painting. Like *The Diver* this work is an early example, roughly square in format, painted on toned paper using gouache. It is tiny and jewel-like in its intensity. It has been dated to around 1875-7, and relates to an oil painting, *Three Bathers*, also of 1875-7 in the Musée d'Orsay and to two pencil sketches, one in a private collection and one in the Collection Noëlle Ratrier, which depict the same figures. Although sometimes known as *Three Bathers* (like the painting in the d'Orsay, *right*), there is another figure at the left of the composition. It is tempting to view Cézanne's *Bathers* as simple pastoral idylls but there are possible darker interpretations. The crouching woman on the lower left throws an arm out to ward off the voyeur in the bushes. Meanwhile, the central figure seems to shelter the head of the kneeling figure on the right, while bringing her hand to her mouth in an attitude of fear or penitence. The story of Diana the Huntress accidentally caught at her toilette by the hapless Actaeon has been suggested as a possible narrative here, but the face has long red hair and appears feminine.

Voyeurism was explored by Cézanne in *A Modern Olympia* (Musée d'Orsay), his obstinate reworking of Manet's famous brothel-scene, which Cézanne exhibited at the first Impressionist show and in which he depicted himself seated before the Olympia figure in an audacious self-portrait. He had met and begun his lifelong liaison with the model Hortense Fiquet in 1869, which he would keep secret from his father until 1886, the year of the older man's death.

Like *The Diver*, the watercolour and gouache are painted over pencil, but this work appears transitional in Cézanne's watercolour style as there are white spaces left. The figures are drawn in pencil, loosely modelled with diagonal hatching and soft curved lines, and built up with dabs of pink watercolour highlighted with white gouache. The foliage and grass are layered on in blocks of different shades of green and blue applied over more loose pencil hatching in box-like diagonal patches. The white gouache areas have discoloured, due, perhaps, to the oxidising of the lead in the white pigment, which occurs when there is sulphur in the atmosphere.

JC

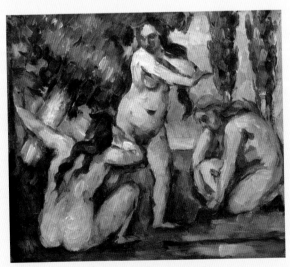

Paul Cézanne (1839-1906), *Three Bathers* 1875-7, Oil on canvas, Musée d'Orsay, Paris © Photo RMN/ © Rights reserved

Edgar Degas (1834-1917)

Dancer Looking at the Sole of her Right Foot

c. 1890s signed 'Degas', undated | bronze, 45.7 cm | NMW A 2458
Purchased by Gwendoline Davies from the Leicester Galleries, London in March 1923

Born in Paris in 1834, Hilaire Germain Edgar Degas studied law before enrolling at the Ecole des Beaux-Arts in Paris in 1855. He was immensely influenced by Jean Auguste Dominique Ingres (1780-1867). Unlike other Impressionists, Degas believed in the importance of draughtsmanship, eschewing the *plein air* approach of artists such as Monet and Pissarro, and his rendering of work is closest in execution to Manet.

Most of Degas' wax models were created after 1880 when, like Renoir, he turned to sculpture after he began to lose his sight. By the time of his death in 1917, over seventy sculptural models were found in Degas' studio. These were largely unknown, even to close friends, since *Little Dancer Aged Fourteen* was the only sculpture exhibited during his lifetime. The wax models included horses, nudes and dancers. Many were broken but those that were intact or could be repaired were cast in bronze in 1921. A. A. Hébrard was the founder who cast the seventy-three works in an edition of twenty-two, lettered A-T.

These sculptures were not intended as finished works but, like sketches, were explorations of form and movement. The figures relate closely to Degas' works on paper and paintings capturing women in both public and private acts. Like Rodin, he captures fleeting moments, freezing his subjects mid-gesture as demonstrated here. This work, which is thought to date from 1890, may be erroneously titled - Degas did not give titles to his sculptures (except for *Little Dancer Aged Fourteen*, when it was named for exhibition).

Titles were historically ascribed by matching sculptures with drawings that indicated original titles. The figure may not be a dancer after all; the pose is not typical of a dancer, and it was not until later in his career that Degas depicted dancers in the nude - at the time of this work's creation he showed them in costume. Indeed, the work bears closer relation to his series of bathers and it may be that it is to this series that *Dancer Looking at the Sole of her Right Foot* belongs.

Whether dancer or bather, this pose is one by which Degas was fascinated and to which he returned in several slightly varying wax models produced over a period of years. One of his models, Pauline, recalled the discomfort of spending hours balancing in this one awkward position. This work, like all the small sculptures, has a rough finish and the face is largely indistinguishable. Degas focuses on the movement of the figure, the muscles of the body and how they are configured whilst she balances. The figure appears wholly entranced: Degas remarked 'My women are simple, honest people, who have no other thoughts than their physical activity'.

LB

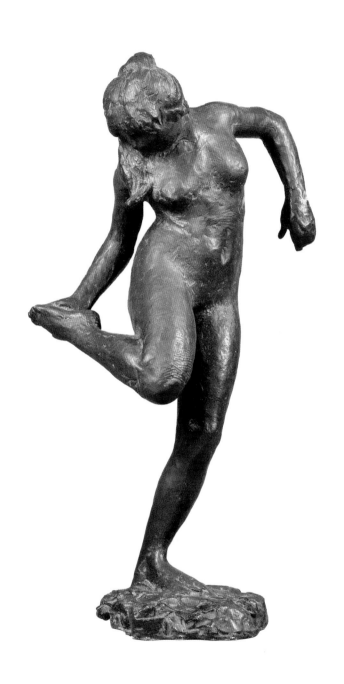

Edgar Degas (1834-1917)

Dressed Dancer, Study

c. 1878-80 signed 'Degas', undated | bronze, 71.7 x 28.25 cm | NMW A 2457
Purchased by Gwendoline Davies from the Leicester Galleries, London in March 1923

This work is one of a number of studies for *Little Dancer Aged Fourteen* (a version of which is in the Tate). The latter was the only sculpture ever to be publicly exhibited by Degas during his lifetime, at which point he was better known for his paintings and works on paper. Degas was fascinated with urban life, and in particular the ballet and café-concerts of nineteenth-century Paris and the people by whom they were frequented. These were places often associated with the 'degenerate classes' and low-life Paris.

Little Dancer Aged Fourteen was the only finished sculpture created by Degas. He initially intended it to be shown at the fifth Impressionist exhibition in 1880 and it is listed in the catalogue. However, it was not finished in time and, although its empty display case was still shown, causing great controversy, the work was not exhibited until the following year. By this time expectations were high and the sculpture caused a great deal of critical debate. As with all his sculptures, the original was created in wax but in order to increase the realism Degas used actual horsehair, satin ribbon, a muslin tutu, satin shoes and a linen bodice in the finished work.

The model was the Belgian dance student from the Paris Opéra Ballet, Marie van Goethem; such dancers were not held in high regard at that time and were termed 'Opéra rats'. During the eighteenth and nineteenth centuries the science of Physiognomy was an ever-expanding area of interest. Physiognomy was the belief that the study of facial characteristics could reveal qualities of an individual's mind or character, specifically their morality. Although once-accepted theories were being continually discredited, the effect on the popular imagination was enormous and these ideas would have been well known by the public. Artists like

Degas began to make use of these modern theories in their work. One of the most influential texts was Benedict Augustin Morel's *The Physical, Intellectual and Moral Degeneration of the Human Species*; the ideas from this text were explored in Emile Zola's novel *Nana* and probably influenced *Little Dancer Aged Fourteen*.

It is clear from the preparatory studies for the finished work, including this one, that Degas altered Marie's physiognomy deliberately, according to modern theories and Morel's text, in order to make her immediately recognisable to the contemporary audience as a member of the degenerate classes. In fact one of Degas' contemporary critics identified the figure as the young prostitute Nana from Zola's book. He alters the size of her lower jaw and her cranium to make her skull more 'primitive' (a sure sign of criminality!), tilting her head further back to emphasise these features. Degas exhibited the sculpture in a specially designed glass case. It was unusual for sculptures to be displayed in cases at this time, and it has been suggested that Degas was drawing further parallels between his work and a zoological specimen from a natural history museum.

LB

Edgar Degas (1834-1917), *Little Dancer Aged Fourteen* 1879-81, Yellow wax, hair ribbon, linen bodice, satin shoes, muslin tutu, wood base. Collection of Mr and Mrs Paul Mellon, Image © 2005 Board of Trustees, National Gallery of Art, Washington

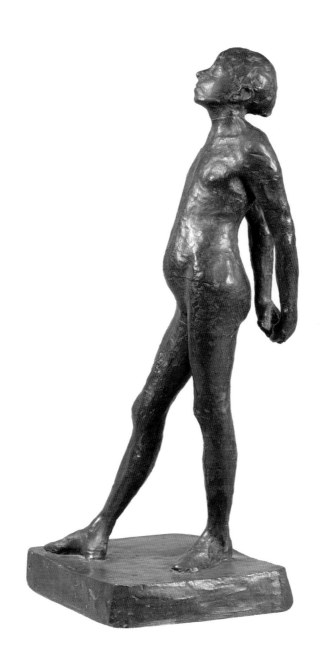

Edgar Degas (1834–1917)

Woman Getting out of the Bath

c. 1900, undated | signed in charcoal, recto, lower left, Degas | pastel and charcoal on cream paper on board, 74.9 x 65 cm | NMW A 2614 | Purchased by the National Museum of Wales in 1977 from the estate of Mrs M. Sacher

Degas developed his pastel technique increasingly from the 1870s on and much of his work from his later career involved pastel. He began to depict women at their toilette and produced over two hundred pastel drawings of bathers during the last two decades of his life. He often used very smooth paper, which is unusual for pastels, as their crumbly texture works well with grainy papers. His technique is also unusual in that he fixed layers of pastel in stages as he worked rather than fixing a finished whole. This enabled him to draw in details over areas of colour. The seductive brilliance of the pastels makes it all too easy to forget the impact they had on their original showing. He exhibited ten *Bathers* at the final Impressionist show in 1886, to varying responses from the critics, ranging from disgust at the perceived subject matter of prostitutes to perverse pleasure, such as that expressed by Gustave Geffroy in his review eleven days after the show opened: '...the woman who does not know she is being looked at, as one would see her hidden behind a curtain or though a keyhole.'

Another reviewer described the figures as 'chaste'. *The Bathers* are a problematic subject, and have attracted interest for their very voyeuristic nature. Were they middle-class wives, as perhaps indicated by their attendant handmaids and the lavish carpets and expensive deep bathtubs? Or prostitutes, as so many contemporary critics insinuated, perhaps due to the fact that their private toilette was placed on public display in the drawings? The identity of the women in these pictures is ambiguous, and since Degas painted and drew bathers in shallow tubs as well as opulent surroundings it is conceivable that he took women from all social groups as his subject matter. Unadorned by a classical narrative, in their very contemporary naturalness, his bathers perhaps embody the modernity Degas and the Impressionists were attempting to convey in their work.

The bathers are often weirdly contorted, stretching to reach a towel or stepping precariously from the tub. Pastel enabled Degas to mould very tactile forms: networks of hatching knit together and take shape in sentient bodies, as in this work, where the hastily drawn zigzag of hatching delineates the side of her torso curving down to her buttock. The more finished rendering of her legs conveys the weight of her body supported on the pedestal of her left leg. Whether she is getting into the bath or out of it is unclear, but the sense of the imminent transfer of weight is palpable. The work appears unfinished, but is signed. There is another work with identical composition to this drawing, whose current location is unknown.

JC

Henri Fantin-Latour (1836–1904)

Larkspurs

1871, signed and dated 'Fantin. 71' | Oil on canvas, 51.2 x 37 cm | NMW A 2461
Gifted through the National Art Collections Fund (Jean Alexander Bequest) to the National Museum of Wales in 1972

Born in Grenoble, Henri Fantin-Latour was an accomplished portraitist and flower painter whose works were popular on the British art market. He was on friendly terms with the Impressionists, painting a number of their portraits, such as *A Studio in the Batignolles* (Louvre, Paris) dated a year prior to this picture. Fantin-Latour studied at the Ecole des Beaux-Arts in 1854 and was a student of Courbet in 1859. He became a friend of Whistler, whom he met in 1858, was devoted to Manet and had close friendships with Morisot, Renoir and Monet. Despite his friendship with these avant-garde artists, he refused an invitation to participate in the first Impressionist exhibition and exhibited regularly at the *Salon* and at the Royal Academy from the early 1860s onwards. Fantin-Latour's flower paintings were particularly important to him as they were his main source of income.

In this typical picture he paints a bunch of larkspurs, the hardy annual of the delphinium family known for its blue, white and pink blooms, as typically seen here, informally arranged in a vase. He brought a new style to flower painting, loading his brush with paint and applying it thickly to the canvas with short brushstrokes. The soft light that he uses gives a particular sensuousness to his work. In later paintings he combined the larkspur with other blooms such as *Roses and Larkspur* of 1885 (Hunterian Art Gallery, University of Glasgow, *right*) or *The Rosy Wealth of June* of 1886 (National Gallery, London), in which he includes lilies in a more formal arrangement. In such paintings his work is reminiscent of the Dutch tradition of flower painting and the work of the French painter Monnoyer. The National Gallery painting was owned by Edwin Edwards of Sunbery, one of his main British patrons, while this work was owned by W. C. Alexander, a friend and patron of Whistler. His popularity with British collectors continued until the end of his life and one of his last paintings of flowers in 1892 also took larkspurs as its subject (Kelvingrove Art Gallery and Museum, Glasgow). The work shows no signs of the dissatisfaction with the genre that is reflected in his letters to his friend the German painter Otto Scholderer at the time. Fantin-Latour was married to another important flower painter, Victoria Dubourg.

Henri Fantin-Latour (1836-1904), *Roses and Larkspur* 1885
Oil on canvas, Hunterian Art Gallery, University of Glasgow,
Scotland/www.bridgeman.co.uk

Henri Fantin-Latour (1836–1904)

Immortality

1889, signed and dated 'Fantin 8'89' | Oil on canvas, 116.2 x 87.3 cm | NMW A 2462
Purchased from Newport Museum & Art Gallery by the National Museum of Wales in 1974

In 1863 Fantin-Latour was in the funeral procession of the great Romantic painter Eugène Delacroix, who was in part at least responsible for reintroducing colour and variety of subject matter into French art. Little official notice was taken of his death and admirers like Fantin-Latour, Manet and Whistler were incensed by this public snub. In the following year Fantin-Latour paid tribute to him with his sombre *Homage to Delacroix*, (1864, Musée d'Orsay, Paris, *page 66*), a group portrait of the artist's many admirers, including himself, gathered around a self-portrait by Delacroix. In 1884, over twenty years after Delacroix's death, a committee was finally set up to produce a lasting monument to him. The committee included Fantin-Latour, along with Puvis de Chavannes, Ribot, Leighton, Alfred Stevens, Durand-Ruel and Dalou. The commission to erect an appropriate cenotaph was given to Dalou. By the spring of 1887 construction had begun in the Luxembourg gardens. Fantin-Latour was involved in the inauguration of the monument in September 1890, but he also wanted to pay his own more personal tribute, and so in early 1889 began preparation for a composition for the *Salon* to honour Delacroix. For inspiration he returned to a drawing he had made to commemorate the death of Wagner for the *Bayreuther Festblatter* (National Gallery of Canada, Ottawa). The drawing *Upon the death of Richard Wagner* (1889, Grenoble, Musée de Peinture et de Sculpture) was of a winged figure of Fame poised over Wagner's tombstone; Fantin-Latour made a tracing of it, eventually deciding to reverse the composition for his new painting. He also made studies from models for the central figure (Lille, Musée des Beaux-Arts). In the final painting, in which Fantin-Latour's technique and use of colour consciously imitate Delacroix,

Henri Fantin-Latour (1836-1904), *Homage to Delacroix* 1864, Oil on canvas, Musée d'Orsay, Paris © Photo RMN/ © Hervé Lewandowski

his *Muse of Immortality* hovers over his hero's indistinct grave in the cemetery of Père Lachaise with the view of Paris beyond including the cathedral of Notre-Dame and the Pantheon, the French national shrine for the nation's heroic sons. Immortality holds the palm of victory and scatters roses on the tomb of Delacroix which is inscribed 'DELACROIX' while rays of light fall across the composition from the unidentified light source.

When the work was displayed at the 1889 Salon it was widely praised. His *Immortality*, 'clothed in mystical rose, so sad and proud, mournful and charming as the sensual pleasures of the mind' was acknowledged by Hamel, while another critic wrote 'It is the work of a sensitive colourist who has a feel for just the right variations and who, especially with greys and purples, achieves harmony. This canvas is painted with the hatching technique normally used by the artist, who may have borrowed it from Delacroix's frescoes in the Church of Saint-Sulpice'. While most critics praised the 'nobility' of the sentiments, it was also noted with some acerbity of Fantin-Latour's motivation for painting such a work: 'Immortality. One wonders whether it was not his own that Fantin wished to achieve'. The artist has heavily worked the canvas, building up layers of textured paint, especially in the area of bright yellow light at the top of the canvas and in the dress of the figure. The head is by contrast much more thinly painted. His repositioning of one of Immortality's wings is clearly visible.

Initially, the attraction of Delacroix as a heroic figure for the Impressionists may seem somewhat unlikely. His choice of subjects, often inspired by biblical stories or the classics, does not seem relevant to the Impressionists with their penchant for landscape and modern life scenes. However, Delacroix's use of colour and freedom of technique in his fresh preparatory studies, which were much admired by collectors, was also appealing, as was his reputation as an artist who distanced himself from the formal academic prescriptions of his day and withstood hostile criticism. Although none of the Impressionists actually met him, his dedication to his art was an important formative example for Degas, Cézanne and Renoir, who in his later years was influenced by his warm palette.

Othon Friesz (1879–1949)

La Ciotat

1907, signed 'Othon Friesz', undated | oil on canvas, 27.3 x 36.1 cm | NMW A 2151
Purchased by Margaret Davies from The Leicester Galleries, London in April 1948

Achille-Emile Othon Friesz was born in Le Havre in 1879. He studied at both the Ecole des Beaux-Arts in Le Havre from 1896 where he met Raoul Dufy (1877–1953), and the Ecole des Beaux-Arts in Paris from 1899 to 1904. Friesz initially produced Impressionist paintings but in 1905, after meeting Henri Matisse (1869–1954), his style changed. Friesz exhibited with Matisse at the Salon d'Automne in Paris in 1905 and it was at this point that the critic Louis Vauxcelles coined the term 'Fauve'. Meaning 'wild beast', it was used to describe the gestural style in which these artists painted, using vibrant colours straight from the tube. The Fauves were influenced by Post-Impressionist artists such as Van Gogh and Neo-Impressionists including Georges Seurat (1859–1891). Other Fauves included Dufy, André Derain (1880–1954), Georges Rouault (1871–1958), Maurice de Vlaminck (1876–1958) and Georges Braque (1882–1963).

It was with Braque that Friesz travelled along the Mediterranean coast from L'Estaque to La Ciotat to paint. This coast was often frequented by the Impressionists and Post-Impressionists, and was immortalised in paintings, most notably in those by Cézanne. La Ciotat was an industrial port surrounded by cliffs and bays, which included the Bec de l'Aigle (Eagle's Beak) and which Friesz used as the subject for several works. It was La Ciotat that provided the inspiration for some of his most lyrical and vibrant work, indeed the drier landscape here caused both Braque and Friesz to alter their palettes to include ochres, pinks and oranges. In this work Friesz captures the Mediterranean landscape perfectly and the hazy sky and coastline are visible through the dramatic slashes of the hot pink tree trunks.

La Ciotat was painted in the last year in which Friesz was truly 'Fauve'. In 1907 he changed direction, producing more representational work inspired by Cézanne's *Bathers*. It was these works that won acclaim at the Salon d'Automne and which were included in Roger Fry's seminal Post-Impressionist exhibition in London, the show that introduced such work to Britain.

This painting originally belonged to Hugh Blaker. Blaker was the brother of the Davies sisters' governess, Jane, and was instrumental in helping them build such an important collection of art. After Jane Blaker's death in 1947, Hugh's art collection was dispersed, at which point Margaret Davies purchased this small landscape. This work is the only example of Fauvism in the collection.

LB

Vincent van Gogh (1853–1890)
Rain - Auvers

1890 | Oil on canvas, 50.3 x 100.2 cm | NMW A 2463
Purchased by Gwendoline Davies from the Bernheim-Jeune Gallery, Paris in April 1920

Van Gogh came to oil painting in 1882, aged 29, relatively late in his tragically short career. He quickly mastered the technique, adopting a highly personal, fluent style with deliberate brushstrokes. This work was painted only eight years after he had begun to work in oil. It dates from the last weeks of his life. The son of a Dutch minister, Van Gogh began his career as a dealer with Goupil before pursuing a brilliant and intense, though not commercially successful, artistic career. However, throughout his life he suffered deep and troubling depression and was constantly supported in his artistic endeavours by his devoted, long-suffering younger brother Theo, also an art dealer.

Following the celebrated and artistically fruitful years in Arles, which ended with a stay in the Saint-Rémy asylum in 1890, Vincent left the south of France. In the May of that year he established himself at Auvers-sur-Oise, about twenty miles north of Paris. He lodged at Café Ravoux and was treated for depression by Dr Gachet. Although clearly mentally troubled this was a tremendously productive period for him. The endless fields around Auvers in the Oise Valley had inspired Pissarro and Daubigny before him, and Van Gogh was no doubt aware of this. Despite being close to Paris, the landscape is remarkably open, with the villages tucked into the valley bottoms almost out of sight with only the roofs and poplar tree boundaries visible. Van Gogh captures the landscape of the region with geological accuracy, reflecting the Tertiary rocks of the Paris Basin with plateau-like horizontals, as commented on by modern geologists.

A fellow artist at the Café Ravoux observed that Van Gogh stored his paintings 'helter-skelter in the dirtiest little corner one can imagine, a sort of hovel where goats are kept'. It has

Vincent van Gogh (1853-1890), *The Bridge in the Rain (after Hiroshige)*
1887, Oil on canvas, Van Gogh Museum, Amsterdam

Vincent van Gogh (1853-1890), *Wheatfield under Thunderclouds* 1890, Oil on canvas, Van Gogh Museum, Amsterdam

been suggested that the result of this haphazard storage is noticeable in this painting on the left-hand side, where the paint surface has been flattened, although some of this flattening may also be due to relining. As in other contemporary pictures he painted in the fields, such as *Wheatfield under Thunderclouds*, 1890 (Van Gogh Museum, Amsterdam, *left*), he adopted a similar long, panoramic format. In the present picture the small town of Auvers is visible spreading along the banks of the Oise tucked between the rolling hills. In letters to his brother at the time he wrote 'the crows flying in circles over the fields give the feeling of sadness and utter loneliness' and he records painting 'immense expanses of wheat beneath troubled skies and I have not hesitated to express sadness, extreme solitude'. The driving rain, so fundamentally difficult for artists to portray, adds to the sense of gloom. Van Gogh captures the essence of rain in bold, graphic lines inspired by contemporary Japanese prints which he and his brother had begun collecting and Vincent then copied. His 1887 copy of Hiroshige's *Bridge in Rain* (Van Gogh Museum, Amsterdam, *page 70*) illustrates his careful observation of the technique for capturing the effect of rain. It was overlooking this same landscape a few weeks later that Van Gogh, obsessed with the fear of being a burden to his newly married brother, shot himself, dying of his injuries the following day aged only 37. Theo himself died just six months later.

Leon Augustin Lhermitte (1844–1925)

The Return of the Harvesters

c. 1890, undated | Signed, lower right, in black chalk, L Lhermitte | pastel and charcoal on buff paper over canvas, 35 x 45.1 cm | NMW A 1692 | Purchased by Margaret Davies from Arthur Tooth & Sons, London in July 1912

France in the 1870s saw an increase in the market for drawings and watercolours, which were more affordable to the new breed of bourgeois art collectors. In 1879 the Société des Aquarellistes Français (the Society of French Watercolourists) was established. New magazines were being published that showcased the graphic arts, such as *La Salon Illustré* and *La Vie Moderne*. In this context of an increased interest in drawings, the fourth Impressionist exhibition in 1879 featured the largest number of works on paper of any of the Impressionist shows, with a third of the total works shown being drawings or gouaches.

Lhermitte was one of the many artists proposed by Degas to submit to the 1879 show. Although contemporary with the Impressionists, Lhermitte developed the style and subject matter of the Barbizon artists through his strong *fusains* (charcoal drawings) of rural scenes, and did not experiment with Impressionist methods until 1906. He was born at Mont-Saint-Père, and came to Paris to train in the early 1860s, showing at the *Salon* and later at the shows of the Société des Aquarellistes Français. He always exhibited finished drawings and became successful through them at the 'Black and White' exhibitions in London. He was in London in the later 1860s and during the Franco-Prussian war, where he met Durand-Ruel.

He began to use pastels in the 1880s. This finished pastel possibly dates from the 1890s, as its composition is close to others of that period, where Lhermitte places the figures off-centre, choosing to develop the depiction of the landscape. It is more resolved than a typical Impressionist drawing: the prismatic yellows, blues and violets of the Impressionist palette are blended with earthy hues to evoke the fading splendour of a dying sunny day. The sun setting over the workers wending their way home is a visual metaphor, lending an elegiac quality to a depiction of a way of life threatened by mechanisation. It is not clear whether Lhermitte is idealising the peasant lifestyle or already nostalgic for its imminent loss. With Millet, Lhermite was admired by Van Gogh.

JC

Edouard Manet (1832-1883)

Effect of Snow at Petit-Montrouge

1870, inscribed 'à mon ami H Charlet/ Manet/ 28 Xbre 1870' (while paint was still wet) | Oil on canvas, 61.6 x 50.4 cm | NMW A 2468 | Purchased from the Durand-Ruel Gallery, Paris by Gwendoline Davies in October 1912

Manet painted this small, bleak work during the Franco-Prussian War (1870-71). It has been described as his first Impressionist painting. A patriotic Parisian, when the Prussians threatened the city of his birth in the autumn of 1870, he did not flee but packed his family off to the safety of the Pyrenees and volunteered for the National Guard. The siege continued throughout the cold winter months and Parisians shivered and starved. By November, Manet had joined the artillery and by December, the General Staff. Cold and with little to eat, he and his fellow soldiers were also bored. 'You have no idea how dreary it is' he wrote to his wife in November 'our state of boredom is such that we don't want to see anyone - always the same conversation, the same illusions. The evenings are hard to bear'. But during daylight hours there was time for painting. In another letter to his wife he wrote 'My soldier's knapsack serves ... to hold everything necessary for painting. I shall soon start some sketches from life. They will be souvenirs that one day will have value'. This painting is the only work of this category to survive.

In late December Manet found himself in a part of Paris he would not usually frequent, Petit-Montrouge, a *quartier* in the south of the 14th arrondissement. He was there on 22 December to see his brother Eugène, also in the Guard, and according to the inscription on this painting Manet returned again on 28 December. The work was probably dashed off in one swift sitting. The foreground is an empty snow-covered wasteland and the Church of St Pierre de Montrouge with its exceptionally tall bell-tower dominates the distance. It was a relatively new building, begun only seven years earlier in 1863. During the siege of Paris, the church served as a field hospital and the tower was used as a look-out post. The greys, beiges and dirty white tones were applied forthrightly by Manet with broad brushstrokes on his small canvas of fine linen, perfectly capturing the dreary half-light of a snow-laden winter's day. No underdrawing is discernible, further suggesting an on-the-spot sketch dashed off between his duties. Bored, cold and suffering from sores, Manet appears to have inscribed the work there and then whilst the paint was still wet and dedicated it to *H. Charlet*, at present a still unidentified fellow soldier.

Another work, *La Gare du Chemin de Fer de Sceaux*, of the exact same dimensions, also dedicated to a comrade and bearing the same date, is lost. These are the only two known paintings from this period. The title of the missing painting may however be incorrect: although Sceaux is only about five miles from Petit-Montrouge, and therefore easily visited on the same day, it was beyond the Prussian lines at that time, making it inaccessible to Manet. Only one month later on 30 June the artist was writing to his wife that peace terms had been signed at Versailles, 'It is all over ... I hope to come and take you in my arms as soon as possible'. This work was among the first Impressionist paintings acquired by the Davies sisters in October 1912, when they also purchased views of Venice by Monet.

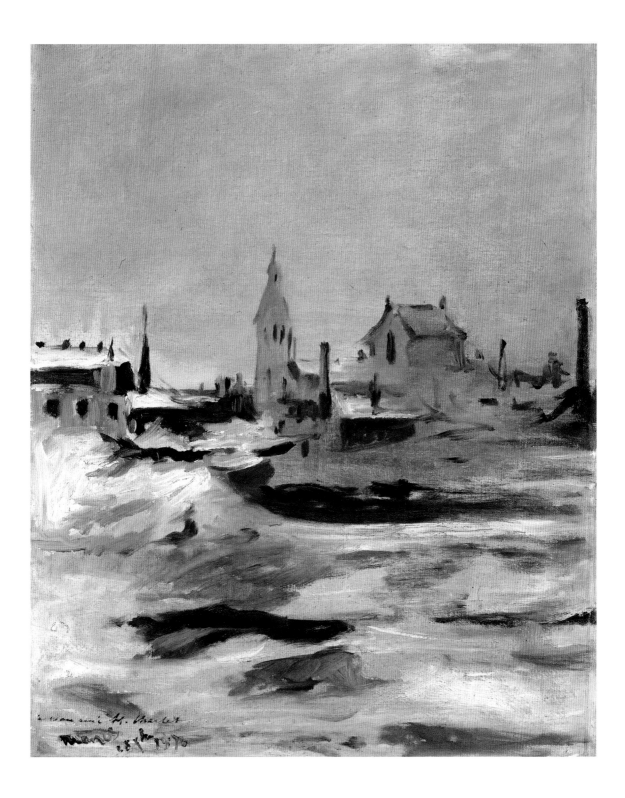

Edouard Manet (1832–1883)
Argenteuil - Boats

1874, undated and unsigned, but stamped 'EM' in red at both lower left and right hand corners | Oil on canvas, 58.5 x 80 cm | NMW A 2467 | Purchased by Margaret Davies from the Bernheim-Jeune Gallery, Paris in April 1920

The small suburban town of Argenteuil, situated ten miles north-west of Paris on the River Seine, was a key site for the Impressionist painters. A town of contrasts, Argenteuil was as much known for its tanneries, silk mills, ironworks and gypsum mines as it was for its renowned boating club, annual races and festivals on the Seine and its popular tree-lined promenade. It was only a fifteen-minute train journey from central Paris and was therefore a popular destination for well-to-do Parisians. Although the town was extensively damaged during the Franco-Prussian War, it was quickly rebuilt. Manet was familiar with the area, as his wealthy family had a home at nearby Gennevilliers on the other side of the Seine where he had spent his summers in the 1850s and 1860s, and it is probably he who introduced Monet to the area.

Shortly after the close of the first Impressionist exhibition in July 1874, Manet visited Monet at Argenteuil where the latter had recently settled and where Renoir later joined them. For Manet it was a revolutionary experience as he began to explore further the merits of *plein air* painting and while there he produced some of his best known work. Here he uses a fine weave canvas that he prepared himself with a pinkish ground. He used this ground in the sketchy painting of the sky, deliberately leaving areas exposed. In this directly observed sketch, with its muted colour combinations, he takes a view from the banks of the Seine at Petit Gennevilliers looking across the water to Argenteuil's floating laundry houses and promenade with the smoke of a factory chimney visible beyond. It appears to be the product of only a few working sessions in front of the motif. In the nineteenth century, it would have been considered a sketch. The bravura application of paint, especially in the sky where the energetic brushwork is

obvious, suggests it is a spontaneous response to the river scene. In contrast however, the foreground focus on the three boats with their bows and masts evenly and precisely arranged, particularly in relation to the laundry boats behind, is carefully composed, suggesting that it might in actuality be a studio study. Manet's virtuoso talent could easily have enabled him to produce such a painting indoors, away from the motif. However, whether painted indoors or out, it shows Manet's masterly talent when balancing apparent spontaneity with considered calculation.

Compositionally, the work is closely related to *Seine at Argenteuil* (1874 Private Collection on extended loan to the Courtauld Institute of Art Gallery, London, *below*). Possibly, this picture was a first attempt at a composition that Manet then broadened to create the finished work with a woman and child at the water's edge. In the completed later painting his palette is lighter and Manet rearranges the boat masts, placing them at more realistic angles and with a more naturalistic relationship to the laundry boats behind.

Edouard Manet (1832-1883), *Seine at Argenteuil* 1874, Oil on canvas, Private collection, on extended loan to the Courtauld Institute of Art Gallery, London

Edouard Manet (1832-1883)

The Rabbit / Hare

1881 | Oil on canvas, 97.5 x 61 cm | NMW A 2466
Purchased by from the Bernheim-Jeune Gallery, Paris by Gwendoline Davies in April 1917

Manet is recorded as saying 'Still-life is the touchstone of the painter' and throughout his career he painted bowls of luscious fruits, pretty flowers, food and dead game. One-fifth of his overall output was pure still-life painting, and still-life details are often prominent in his larger compositions. This work, which was conceived as one of four decorative panels, dates from the end of Manet's life when he had begun to turn his attention to large, decorative ensembles. In 1879 he proposed a series of paintings for the meeting chamber in the new Hôtel de Ville in Paris but the project came to nothing. By 1881 his health was in decline and he was suffering severe pains in his legs. He spent the summer months working at a villa in Versailles where he began a new decorative cycle. Two of the four panels represented hunting trophies: this rabbit, which has also been described as a hare, hanging outside a closed window, and *The Great Horned Owl* (Bührle Collection, Zurich) shown against a grained wood wall. The third and fourth pictures illustrate part of a vine on a trellis and the corner of a garden respectively. Two further works painted a few years earlier, of a vase of flowers and a watering can, may also be related to this cycle. They were all recorded together as a group in an inventory taken in Manet's studio at the time of his death. In any case, the paintings do not seem to have reached their intended destination.

It is interesting to compare this late picture, painted to be viewed from a distance as part of a cycle and therefore in a bold, loose style, with his earlier depiction of a rabbit: *The Rabbit* (1866 Fondation Angladon-Dubrujeaud, Avignon, *right*) is painted much more in the tradition of French still-life painting, and appears to be a tribute to Chardin. The earlier work is altogether more conventional; the animal's fur is beautifully rendered with grace and there is an air of theatricality and unreality about the presentation. The later picture has a much more casual and yet confident composition, with rapid, free broad brushstrokes suggesting the varied textures - from the animal's white tufted tail and long ears to the white curtain behind the closed window and climbing plant in the foreground.

This work was submitted to the *Salon* in 1882 but was rejected. Sold after his death in his studio sale to the dealer Durand-Ruel, it was eventually purchased by Gwendoline Davies from Bernheim-Jeune in 1917 and exhibited the following year along with other paintings from the Davies collection in an exhibition organised at the Victoria Art Gallery, Bath.

Edouard Manet (1832-1883), *The Rabbit* 1866, Oil on canvas, Avignon (F) Musée Angladon, cliché C. Loury

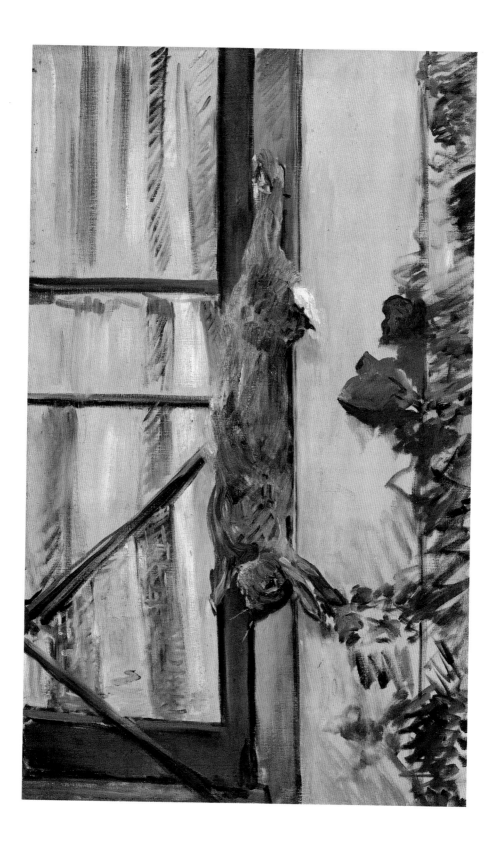

Claude Monet (1840–1926)
The Pool of London

c. 1871, signed 'Claude Monet' lower left in black paint, undated | Oil on canvas 48.5 x 74.5 cm | NMW A 2486
Purchased by the National Museum of Wales from the Robert Noorman Gallery, London in 1980

In September 1870 when a Republic was declared in France and Paris was besieged by the Prussians, Monet fled to England to avoid being conscripted into the army. He settled in London where he was soon joined by his new wife Camille and their young son Jean. Monet knew the hardship and misery of the Algerian War, in which he had served in 1861. Now married and with responsibilities, and having lost his close friend Bazille in the early stages of the Franco-Prussian War, he wanted to avoid conflict. Monet spent his time in London visiting museums and discovering the works of Constable and Turner and frequenting cafes. He was still a young, unknown artist with little money. Thirty years later he recalled it as 'the miserable time passed here'. However, he made some useful contacts for the future. Through the artist Daubigny he was introduced to the dealer Paul Durand-Ruel, and by December 1870 one of his paintings, a Trouville seascape, was included in the dealer's first London exhibition. The following year Durand-Ruel began to purchase Monet's work seriously, acquiring this one in 1872. He began to build Monet's reputation in America and by 1893 this work was in an American collection. Durand-Ruel also informed Monet that Pissarro was in London and so the two artists spent time together. This was not a prolific time for Monet, but both he and Pissarro exhibited their work in the International Fine Arts Exhibition at Kensington in May 1871. Monet painted Hyde Park, and with his interest in the sea and maritime themes he was drawn to the river Thames. His best known painting of the Thames is *The Thames below Westminster* (1871 National Gallery, London, *page 85*). The news from Paris was increasingly alarming, and Monet's mood was far from buoyant. It seems that Monet did not fully appreciate London and its fog as a potential subject for his landscapes at this stage, and was not to do so until he returned for an extended period in the autumn of 1889.

In this work the colours are muted and dull, perfectly capturing a bleak and dreary winter's day in London by the Thames. Monet is situated at Tower Stairs, near the Tower of London, and records a view of the Custom House on the left with the tower of Billingsgate Fish Market and the tower of the church of St Magnus the Martyr beyond and the distant silhouette of London Bridge. Familiar with maritime observation from his upbringing in Le Havre, Monet observes the shipping details carefully. He treats the river surface broadly but notes the foreground barges more crisply, one with sails furled, another with sails set out on the left and a schooner moored at the quay on the right. A number of Thames lighters used for unloading cargo are moored in the river. This work is a pair with a painting in a private collection (*page 84*), which shows the same view but with more complex loading procedures in the foreground. It would seem to have been painted at the same time in similar light conditions. Monet was interested in the work of the American artist Whistler, whose etching *Billingsgate* of 1859 takes a similar view to both these pictures. Whistler's Thames etchings made his reputation and were finally published as a set in London in May 1871.

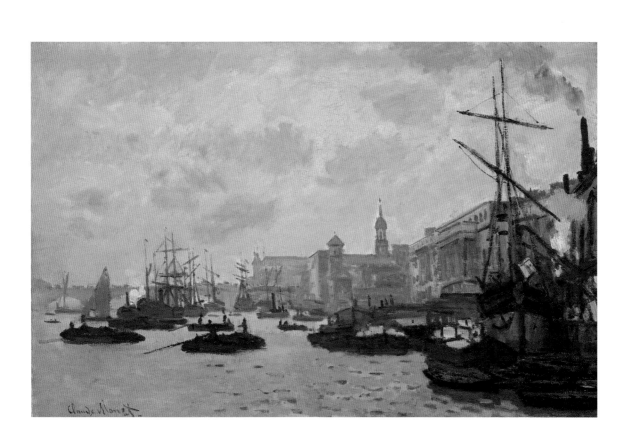

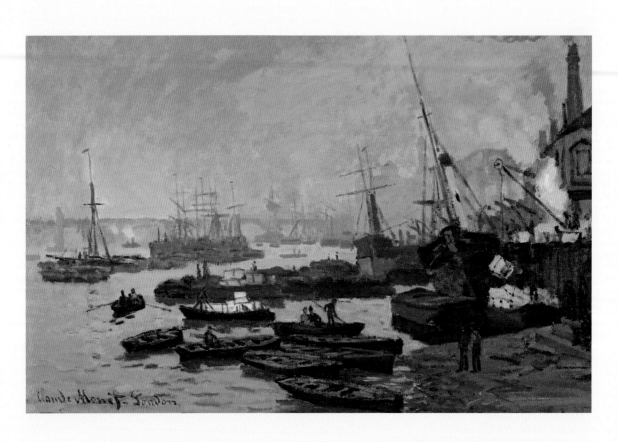

Claude Monet (1840-1926), *Boats in the Pool of London* 1871, Oil on canvas, Private collection/www.bridgeman.co.uk

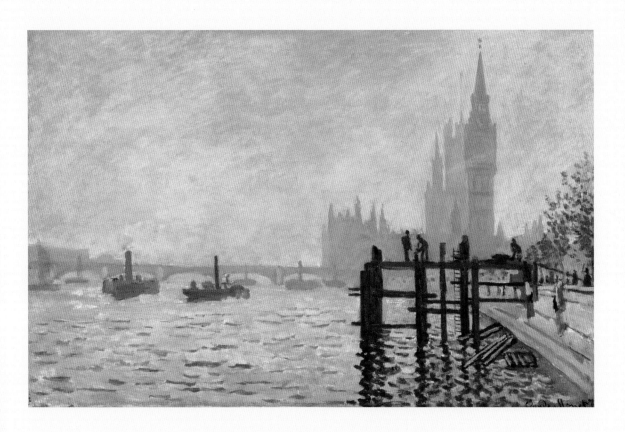

Claude Monet (1840-1926), *The Thames below Westminster* 1871, Oil on canvas, © National Gallery, London

Claude Monet (1840-1926)

Rouen Cathedral: Setting Sun (Symphony in Grey and Pink)

1894, signed and dated 'Claude Monet 94' | Oil on canvas 100 x 65 cm | NMW A 2482
Purchased by Gwendoline Davies from the Bernheim-Jeune Gallery, Paris in December 1917

In the 1890s, Monet devoted himself to his 'series' paintings in which he observed the detailed changing effects of light first on haystacks, then poplars and finally on the west facade of the cathedral of Notre-Dame in the centre of Rouen. Monet began his obsessive work at Rouen in late January-February 1892. He had never previously focused so exclusively on one specific building, but knew the city well having painted there previously in the 1870s. His subject was significant - one of the oldest structures in Normandy, begun in the twelfth century and completed 400 years later, thus illustrating the entire development of the Gothic style. It had already attracted the attention of a number of French and British artists including Turner and Bonington. Monet established a studio on the square in front of the cathedral. From this viewpoint he observed the facade at an angle, which is how the cathedral appears in most of his paintings. He worked for three months but found the task daunting, the weather changeable and the building immensely complex. In his letters to his long-term companion Alice Hoschedé he revealed, 'How hard it is, yet it is working out ... I had a night filled with bad dreams: the cathedral collapsing on me, it seemed to be blue or pink or yellow'. By mid-April he was back at Giverny 'absolutely discouraged and unhappy'. The following year he returned to Rouen in February so that the light would be the same. He worked furiously then returned to Giverny in April, where he continued to work on the paintings until 1894. It was at this point that Monet signed and dated twenty of the pictures, hence the date '1894' although he had worked on them in 1892 and 1893. It was not until May 1895, three years after the series had been started, that the sequence of twenty pictures, including this work, finally went on display in Paris at Durand-Ruel's gallery.

This painting focuses on the west facade with the great rose window above the central door, the Tour d'Albane and the edge of the Tour de Beurre on the right. Chronologically, it seems to be the latest of the afternoon effects, painted about 6.30 pm, the late afternoon light cascading down the facade and purplish shadows dissolving the detail of the building, which contrasts with a turquoise blue sky behind. It is interesting to compare it with another sunset view of the cathedral at the Musée Marmottan, *Rouen Cathedral, Effects of Sunlight, Sunset*, which has warmer, yellower tones, seems less finished and is unsigned.

The exhibition was a great critical success. There was a general revival of interest in Catholicism in France in the 1890s and although Monet was not religious and did not specifically reproduce any of the religious sculpture on the facade, he would have been aware of the movement and the fact that his paintings would cause interest. It was also a period of nationalistic revival. One reviewer, Clemenceau, devoted the entire front page of his paper *La Justice* to the show under the eye-catching title 'La Révolution des cathedrales' and called on the French President Félix Faure to buy the entire series for the nation. This plea was ignored and the series is now scattered internationally, although five are at the Musée d'Orsay in Paris. Monet's friend Pissarro, who also painted in Rouen in the 1880s (*page 111*), lamented this fact in a letter to his son Lucien: 'His Cathedrals are going to be sent here and there, even though the series really needs to be seen as a whole'.

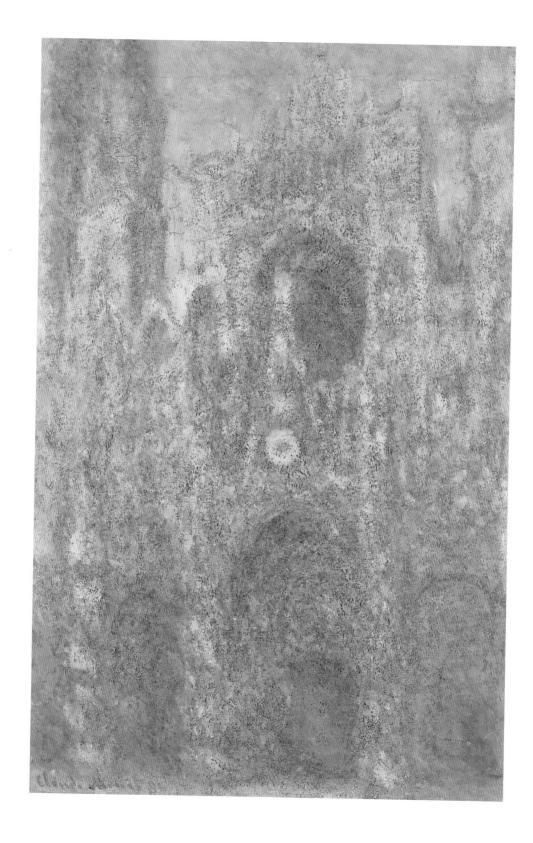

Claude Monet (1840-1926)

Charing Cross Bridge

1902 | Oil on canvas, 65.4 x 81.3 cm | NMW A 2483
Purchased by Margaret Davies from the French Gallery, London in May 1913

Monet had returned to London on a number of occasions after his initial visit during the Franco-Prussian War, but only found himself inspired to paint the city again in the autumn of 1899. By then he was 59 years old and commercially successful, so he and his second wife Alice Hoschedé could afford to stay in the palatial surroundings of the Savoy Hotel. This may have been recommended to them by Whistler, who had stayed there in 1896 when he made a series of Thames lithographs. Not only was the accommodation luxurious, it also enjoyed excellent views of the Thames with its numerous bridges and the houses of Parliament beyond. He was drawn to the atmospheric appearance of London's new landmarks on the river – Waterloo Bridge, Charing Cross Bridge and the Houses of Parliament as well as the Embankment, all constructions of the previous century. He became famously fond of London's fogs, recalling 'I so love London! But I love it only in winter. It's nice in summer with its parks, but nothing like it is in winter with the fog, for without the fog London wouldn't be a beautiful city. It's the fog that gives it its magnificent breadth'. Monet began work on three simultaneous series, sitting at the window of his hotel room on the sixth floor where he had views of Charing Cross Bridge from the right (of which there would eventually be thirty-five paintings) and Waterloo Bridge to the left (of which he would eventually produce forty paintings). He changed the paintings as the light shifted and returned in early November to France with unfinished canvases, knowing that he would need to return for further observation.

Monet's Thames series was a major undertaking and he was in London again in February 1900 with his pictures but was perplexed to find that although he had been promised the

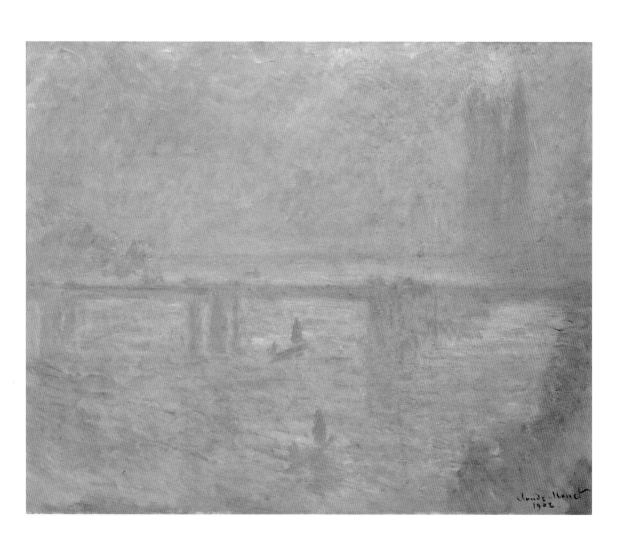

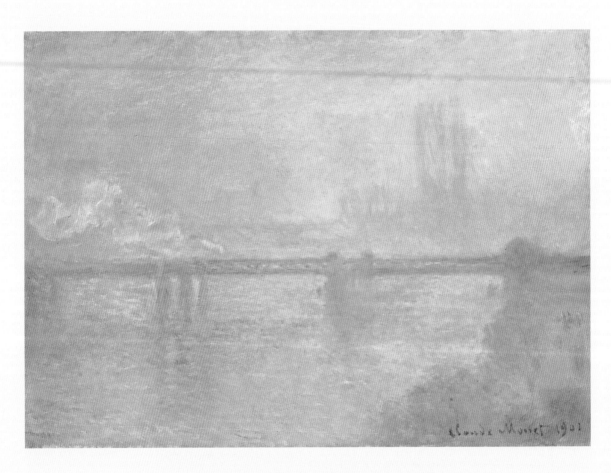

Claude Monet (1840-1926), *Charing Cross Bridge* 1901, Oil on canvas
Mr and Mrs Martin A. Ryerson Collection, 1933.1150 Reproduction, The Art Institute of Chicago

same rooms they had been selected by Princess Louise for wounded soldiers returning from the Boer War. Instead, he had to make do with two rooms on the floor below. He had already begun the Charing Cross Bridge and Westminster Bridge series, but now he began the views of the Houses of Parliament as well. He worked quickly. By 1 March he had forty-four canvases under way, by 4 March this had increased to fifty, by 18 March sixty-five and when he returned exhausted to Giverny in April he had no fewer than eighty canvases with him. He was back in London in January 1901, when his crates of paintings were delayed by Customs. He was still working on the bridge scenes in late February and recorded that he found the changeable weather conditions disruptive. In March he fell ill and so returned to France where he completed the remainder of the paintings, working on them until 1902. In all he produced eighty-five London views, thirty-five of which were selected by Durand-Ruel for his May 1904 exhibition, which was financially extremely successful.

The present painting was completed in France and was offered by Monet in a charity raffle to benefit the victims of a major flood in May 1910. It is not known who won the work but by late 1910 it was with Durand-Ruel, from whom it was purchased by the Duke of Marlborough. He had sold it to the French Gallery by 1913, when it was purchased by Margaret Davies, mistakenly entitled *Waterloo Bridge*. It in fact shows the railway bridge into Charing Cross station, designed by Sir John Hawkshaw and completed in 1863. It had nine spans supported by cylinders sunk into the bed of the Thames. Its distinguishing original wrought-iron lattice work of the girders is not clearly depicted here as in some of the paintings in the series such as *Charing Cross Bridge* (1901 Art Institute of Chicago, *left*) and this may account for the confusion with the Waterloo series. The bridge was much altered in 1979 and is now a very different structure from that which Monet depicted.

The Savoy Hotel viewed from the Embankment, 1893.
Reproduced by permission of English Heritage. NMR

Claude Monet (1840–1926)

Waterlilies

1905, signed lower left and dated 'Claude Monet 1905' | Oil on canvas, 81.9 x 101 cm | NMW A 2484
Purchased by Gwendoline Davies from the Bernheim-Jeune Gallery, Paris in July 1913

In 1883 Monet, his long-term companion Alice Hoschedé and their combined household of eight children moved to Giverny, sixty-seven miles north-west of Paris, and rented the 'Pink House' where Monet was able to indulge his passion for gardening. He planned, planted and tended the grounds and in 1890 purchased the house and surrounding land. In 1893 he acquired a further meadow with a pond on the south side of the property, separated from it by a single-track railway line and dirt track. It was on this land that Monet created his famous water garden. In applying for planning permission to the Giverny Town Council he stated that he intended to construct a garden for 'the pleasure of the eye and also for motifs to paint'. This was no small undertaking. He needed to produce a regulated water supply and therefore divert the River Epte and introduce a system of sluices. The local residents were not entirely supportive and it took some time before work could begin. The initial project was completed in the autumn of 1893 including the planting of trees and a Japanese style bridge. Monet enlarged the pond in 1901, 1903 and 1910, on each occasion increasing the water surface and making more room for the cultivation of waterlilies. Although Monet ventured to Venice and to London to paint series of works, the gardens at Giverny remained the principal inspiration of his later years. His first series of waterlilies went on display in 1900 and his second series was begun in the summer of 1903 and culminated in the autumn of 1908. Initially he included in his compositions the pond banks, the weeping willows, azaleas and wisteria and his Japanese bridge. It was only in 1905, when this work was painted, that he started to eliminate any such features and began to concentrate on the surface of the pond as an entity in itself. This painting perfectly illustrates this development. Between 1905 and 1907 he executed twenty-four canvases, many of which have a nearly square format (*page 95*). Starting early in the morning, he would set up his easels on the Japanese bridge, adopt a viewpoint looking down directly on the water surface and spend the day recording the effects of the changing light on the reflections and waterlilies below.

Although Monet tended much of the garden himself he gradually found it necessary to employ a head gardener and eventually five assistants as well. One gardener was dedicated full time to the maintenance of the waterlily garden to facilitate Monet's painting of it. Rowing in a small boat the gardener would remove moss, algae and water grasses for Monet, who insisted on clarity. The waterlilies were inspected daily, fertilized at the roots and the dead blossoms and leaves removed. The remaining leaves were washed, as they collected dust from the nearby track. Eventually, Monet paid for the dirt track to be improved so the dust would no longer disturb his plants, but he always regretted that the track and railway divided his property as it did.

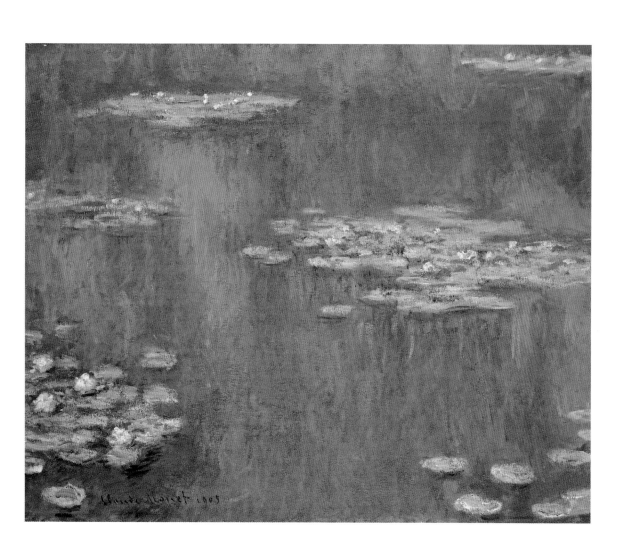

Claude Monet (1840–1926)

Waterlilies

1906, signed lower left and dated 'Claude Monet 1906' | Oil on canvas 81.6 x 92.7 cm | NMW A 2487
Purchased by Gwendoline Davies from the Bernheim-Jeune Gallery, Paris in July 1913

Monet's move to Giverny and subsequent fascination with the lily pond he created there dominated the latter years of his career. The decorative paintings he produced there are now some of the most popular and reproduced images of our time. Monet wrote of the experience of creating his garden, 'It took me some time to understand my water-lilies ... I had planted them purely for pleasure; I put them in without thinking of painting them. A landscape doesn't get to you in a day. And then suddenly it dawned on me how wonderful my pond was, and I reached for my palette'. This slightly romantic version of his motives is belied by the fact that he mentioned when applying for planning permission his desire to create a motif for painting.

The clear water of the ponds that Monet insisted were so carefully maintained supported clusters of lilies, and reflected trees and shrubs he had personally selected as well as the passing clouds in the sky above. Monet produces a complex space in which the real and reflected world is as one, constantly echoing each other. This painting, with its blue and green tones, typically has a slightly mystical sense of space and solitude reminiscent of oriental art. Monet painted his waterlilies from his Japanese bridge, and his studio was filled with portfolios of Japanese flower prints by Hokusai, and others were pasted to the walls. His garden was full of flowers and flowering shrubs from Japan including bamboo and Japanese apricots. He later wrote 'I have the deepest admiration for Japanese art and a great sympathy for the Japanese'. Monet entitled his paintings *Nymphéas*, the scientific name for the variety of white waterlily that he and his gardening team nurtured in Giverny. His first two series of waterlilies were exhibited at the Durand-Ruel gallery in 1900 and 1909, the second being an enormous critical success. The fame of Giverny and Monet's waterlilies spread, and despite the artist's longing for solitude in order to work, visitors now regularly made the trip to see him in his gardens. They included old friends like Sisley and Pissarro, even Cézanne and the critic Geffroy, but new admirers came too including Emile Blanche, Pierre Bonnard and John Singer Sargent.

Claude Monet in his garden at Giverny, Black and white photograph by Roger-Viollet, Paris, Private collection

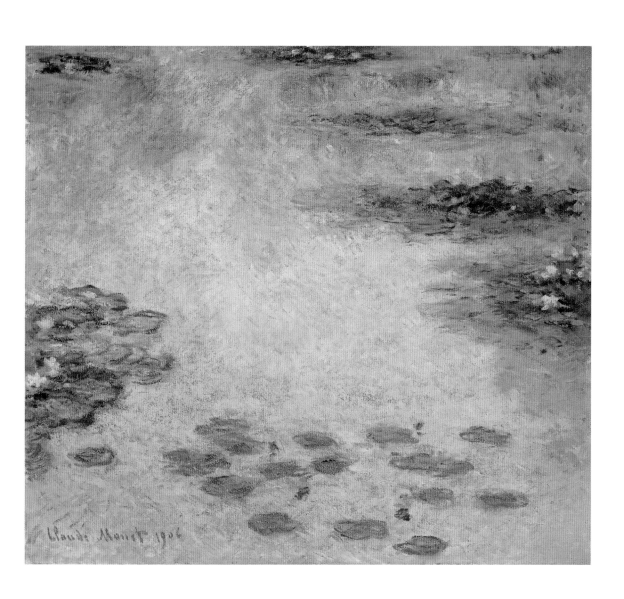

Claude Monet (1840-1926)

Waterlilies

1908, signed and dated lower right 'Claude Monet 1908' | Oil on canvas 100.5 x 81.3cm | NMW A 2480
Purchased by Gwendoline Davies from the Durand-Ruel Gallery, Paris in July 1915

'These landscapes of water and reflection have become an obsession. They are beyond the powers of an old man, and yet I want to succeed in rendering what I perceive' Monet wrote in 1908, the year he painted this work. And indeed he succeeded in doing so, for in the following year his most successful and significant exhibition in the twentieth century opened at the Durand-Ruel Gallery. It was entitled *Les Nymphéas: Séries de Paysages d'Eau* and comprised forty-eight works he had painted at Giverny between the summer of 1903 and the autumn of 1908. Monet worked carefully with Durand-Ruel on the selection of the canvases and they hung the show in three distinct groups. Many of the early pictures were dropped, leaving only one example from 1903. Five paintings from 1904 were included and seventeen from 1905-7. All four of Monet's experimental circular canvases were selected and fourteen of the vertical format pictures. This painting was exhibited as part of a final group of seven pictures of waterlilies painted in 1908. Although the viewpoint is high in all the waterlily paintings in the Davies sisters' collection, here it seems to rise almost vertically, and Monet's palette is much lighter, with an increased use of yellow and green. The waterlilies and their elliptical leaves are mostly dabbed or stroked in. Although many works were sold prior to the show opening, this one remained in the artist's ownership and was lent by him as 'no 42'. Three weeks later, he let Durand-Ruel have it. Gwendoline Davies purchased it in July 1913, with the two other waterlily paintings (*pages 93 and 95*).

The exhibition was a great critical success; Geffroy, Romain Rollard, Rémy de Gourmont, Lucien Descaves and Claude Roger Marx were all immensely enthusiastic. Rollard wrote to Monet personally 'I admire you most of all among today's French artists ... I need only turn to painting, where works like your waterlilies are blossoming, to reconcile myself with the art of our time, and to believe that it stands comparison with the greatest that has gone before.' Monet was appreciative of the publicity and praise. He wrote to Geffroy, who was correspondent for *La Justice*, 'I have received your article on my exhibition. Many thanks. You are always the one who says best whatever there is to say, and it is always a pleasure for me to be praised by you'. All that summer Monet was besieged by enthusiasts and collectors at Giverny. The exhibition marked a watershed and Monet's work was now appreciated increasingly beyond France, not only by the Davies sisters, whose interest was unique among British collectors, but particularly by Americans. For instance, Sarah Choate Sears of Boston was one of the earliest buyers at the exhibition. It is worth noting that although the waterlilies were undoubtedly an obsession for Monet, in the year he painted this work he was also visiting Venice and completing those paintings back at Giverny. His capacity for work was daunting.

Monet himself continued to paint waterlilies until his death in 1926, even though he experienced problems with his eyesight. In 1918 he offered a series of vast canvases to the French State, and on his death, after thirty years of work on them, twenty-two panels were installed in the Orangerie of the Tuileries, which was especially decorated to receive them. In all, Monet painted some 300 paintings on the same theme.

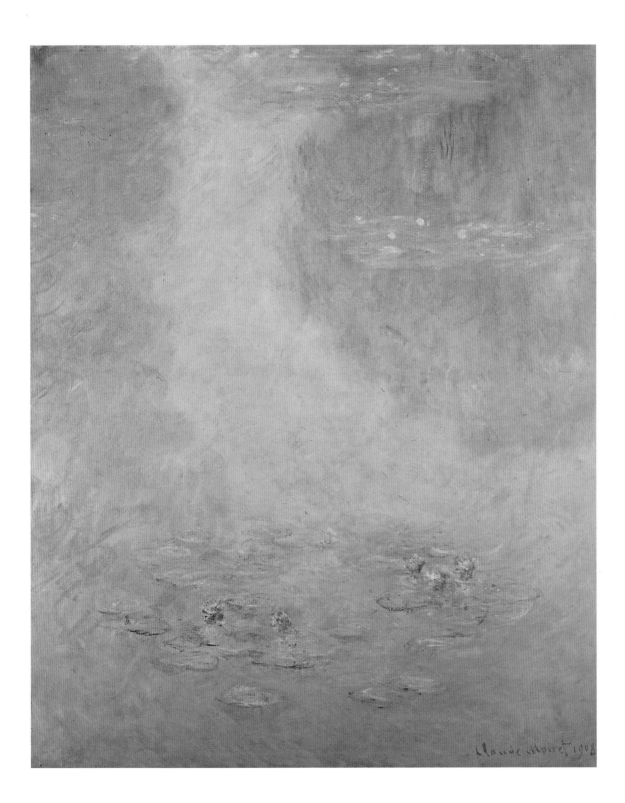

Claude Monet (1840-1926)

San Giorgio Maggiore by Twilight

1908, signed and dated lower right 'Claude Monet 1908' | Oil on canvas 65 x 92.2 cm | NMW A 2485
Purchased by Gwendoline Davies from the Bernheim-Jeune Gallery, Paris in October 1912

Like Boudin before him, Monet visited Venice late in his career. At the age of 68 he and Alice, by then his second wife, embarked on a productive visit from October to December 1908. They stayed initially at the Palazzo Barbaro on the Grand Canal, then moved on to the Grand Hotel Britannia on the north side of the Canal. Monet had been reluctant to visit Venice as it had already been painted by so many other artists, but once there he was captivated, particularly by the Adriatic light and the reflections in the canals. He rose to the challenge and produced an astonishing series of Venetian cityscapes. Modestly, he regretted that he had not visited earlier when he was 'younger and full of daring'. In the evenings of late November 1908 Monet and Alice took gondola trips on the canals, as she recorded, 'to enjoy those splendid sunsets which are unique in the world'.

In this vibrant work, Monet records the monastery and the Palladian church of San Giorgio Maggiore in those twilight moments. The usually starkly white church facade is a purple silhouette, while on the right the dome of Santa Maria Salute is faintly visible in the haze. The view Monet records seems to have been taken looking south-west from near the water's edge, at the end of Via Garibaldi, just south of the bridge over the Rio della Tana. Monet used pure, almost brash colours (particularly the purple, which was relatively new, having only been manufactured in the past forty years) but also bright green and yellow, and he allows the pale grey ground to show through to provide natural highlights in both sea and sky. He probably bought this canvas in Venice, as it bears the remains of a Venetian colourman's label. He painted another San Giorgio Maggiore in the twilight hours, now in Tokyo (Bridgestone Museum, *right*), working simultaneously for two hours alternatively on each of the paintings.

However, his Venice painting was disrupted by Alice's illness - she had leukaemia. They were forced to return to France, which impacted on his ability to complete the pictures. 'I could do views of Paris from memory and no-one would notice but in Venice, it's another matter... Unfortunately I can't stay here', he wrote to Durand-Ruel from Venice in 1908. He worked on the pictures back at Giverny but returned to Venice in 1909, the year the Davies sisters first visited the city. However, he returned to nurse his ailing wife, who died in May 1911, plunging Monet into a deep depression. As a result, his Venetian series of paintings did not go on display in Paris for another year. Twenty-nine of them were eventually shown by Bernheim-Jeune in May 1912 and were almost certainly seen by the Davies sisters. In October 1912, Gwendoline Davies purchased the sisters' first Impressionist paintings, two views of San Giorgio Maggiore (*page 101*) and *Venice, The Grand Canal* (Fine Arts Museum of San Francisco) as well as Manet's early *Effect of Snow at Petit-Montrouge* (*page 77*).

Claude Monet (1840-1926), *Twilight Venice* 1908, Oil on canvas, Bridgestone Museum of Art, Ishibashi Foundation, Tokyo

Claude Monet (1840-1926)

San Giorgio Maggiore

1908, signed and dated 'Claude Monet 1908' | Oil on canvas 55.9 x 78.9 cm | NMW A 2488
Purchased by Gwendoline Davies from Bernheim-Jeune Gallery, Paris in October 1912

This painting of the famous church and monastery of San Giorgio on its island is less dramatic and more subtle in colouration than the previous picture. The classical facade, which was built by Palladio between 1568 and 1580 but completed by Scamozzi, and the later eighteenth-century bell tower are dissolved in a haze of colours - pink, blue, mauve and yellow - giving the buildings an almost ghost-like appearance. During their stay in Venice from October to December Monet's second wife Alice chronicled the changing weather conditions in a series of letters to her daughter. She described the fogs, which were not uncommon at that time of year, as well as the brilliant days of bright sunshine. This view was probably taken from a window at the Hotel Britannia where they stayed initially, near the mouth of the Grand Canal. On the first day Alice recalls that her husband was painting from four o'clock in the afternoon until six o'clock. The lighting in this picture is consistent with observations at that time of day, during Monet's late afternoon 'quatrieme motif'.

There are four versions of this composition. Two works that are larger in scale are in the Art Institute of Chicago (*right*) and the Indianapolis Museum of Art, and two of similar size are in private collections. All show San Giorgio with long shadows and raking light from the west. When this painting was exhibited in Monet's Venice exhibition in Paris in 1912, the composition was described by the critic Geffroy as 'mists at once pearly and sulphurous half obscure the fine church, or else all rosy above the water, it is outlined against a lemon-yellow sky. Gondolas leap up, and, caught by the leaning gondolier's oars, they take flight'. This is one of the first Impressionist pictures purchased by the Davies sisters in October 1912, following their own visits to the city, and illustrates their interest in Monet's most recent output.

Claude Monet (1840-1926), *Venice, San Giorgio Maggiore* 1908, Oil on canvas, Mr and Mrs Martin A. Ryerson Collection, 1933.1160
Reproduction, The Art Institute of Chicago

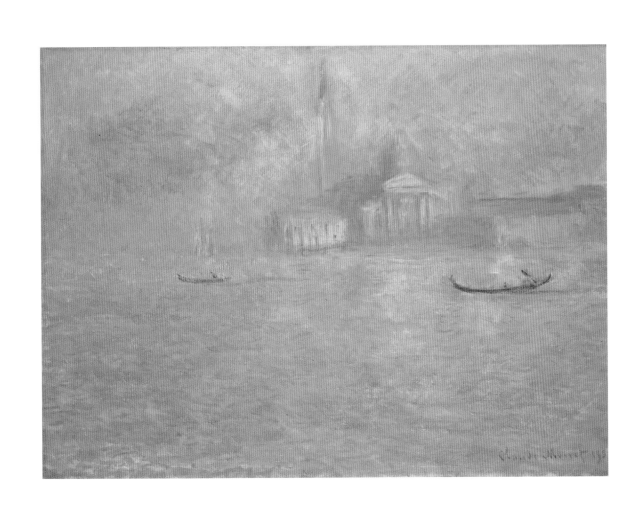

Claude Monet (1840-1926)

The Palazzo Dario

1908, signed and dated 'Claude Monet 1908' | Oil on canvas 92.3 x 73.2 cm | NMW A 2481
Purchased by Margaret Davies from the Durand-Ruel Gallery, Paris in July 1913

The Palazzo Dario on the south bank of the Grand Canal in Venice is renowned for the intricate decorations and brightly coloured marbles of its famous facade. It was built in around 1487 for Giovanni Dario, the Venetian Republic's representative in Constantinople. The building had been on the tourist itinerary since the mid-nineteenth century and was admired and painted by Ruskin, Sickert and the American artist John Lindon Smith. Monet painted the facade after the building had undergone a thorough restoration between 1903 and 1906. Alice Monet records that on 12 October 1908, while they were still staying at the Palazzo Barbaro, her husband worked on the steps of the building. The painting he executed from this viewpoint, *The Grand Canal, Venice* (1908 Museum of Fine Arts, San Francisco, *page 28*) includes a side view of the Palazzo Dario. This work however was painted after they had moved to the Hotel Britannia. On the afternoon of 17 October she recalls that he was working 'in the canal' for his 'troisième motif', that is, the period between two and four o'clock, which he devoted to his painting. The lighting and observations in this work would suggest such a time of day. He painted from a position slightly to the east of the Palazzo Corner della Ca' Grande, already in 1908 the seat of the Prefettura. There was no quay available at this point, so presumably he was working from a gondola or perhaps a floating landing stage outside the Palazzo Minotto, hence Alice's description of him working 'in the canal'.

The vertical format, which may have been inspired by Whistler etchings such as *The Balcony* of 1879-80 (New York Public Library) enables Monet to devote half of the canvas to the reflections in the Grand Canal, with touches of yellow, purple, green and blue. He concentrates on these observations at the expense of the entire top storey and roof of the Palazzo Dario. This cropping of a famous building is reminiscent of his Rouen Cathedral series (*page 87*). The architectural details, the pillars, roundels, arched windows and coloured marbles are all dissolved in the warm afternoon light, as a gondola floats by.

Monet's only surviving drawing from this Venetian visit shows the same vertical view of the Palazzo Dario (Musée Marmottan) as does a small canvas in a private collection. He also produced two landscape views of the building, now in the Art Institute of Chicago and in a private collection. During his stay in Venice, Monet also painted views of the Palazzo du Mula and Palazzo Contarini, also on the Grand Canal.

Claude Monet (1840-1926), *Palazzo Dario*,
Pencil on paper, Musée Marmottan, Paris, France

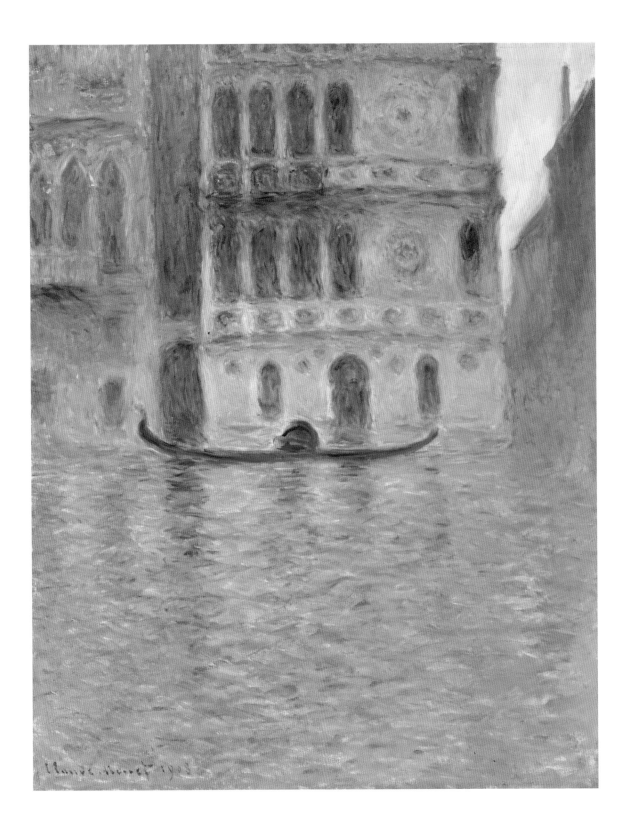

Henri Moret (1856–1913)
Village in Clohars

1898, signed and dated lower left 'Henry Moret/ 98' | Oil on canvas, 54.6 x 65.1 cm | NMW A 2490
Purchased by Margaret Davies from Arthur Tooth & Sons, London in December 1959

Born in Cherbourg, Moret underwent an academic training in Paris with Gérôme and was initially influenced by Corot and other Barbizon painters. Between 1889 and 1890 he was in Brittany with Gauguin and the group of painters working at Pont-Aven. This painting shows the nearby village of Clohars and was painted a few years later in 1898. Around 1895 he had attracted the attention of the dealer Durand-Ruel, who began to exhibit his work. Gradually Moret came under the influence of Monet but he continued to work extensively in Brittany. This work shows a quiet country road in the village of Clohars, leading into a junction with thatched cottages, vivid green hedges and stone walls. While the greens reflect the influence of Gauguin, the picture has a quiet simple intimate atmosphere. Although not as well known as some of the other Impressionists, his work can be seen in other public collections such as the National Gallery of Art, Washington, which owns *The Island of Raguenez, Brittany* of 1890-95 (*right*). Margaret Davies purchased this picture four years before her death, and she no doubt thought that it would complement *Breton Peasant Women at Mass*, which she believed to have been painted by Gauguin (*page 139*).

Henri Moret (1856-1913), *The Island of Raguenez, Brittany* 1890-95
Oil on canvas, Ailsa Mellon Bruce Collection, Image © 2005 Board of Trustees, National Gallery of Art, Washington

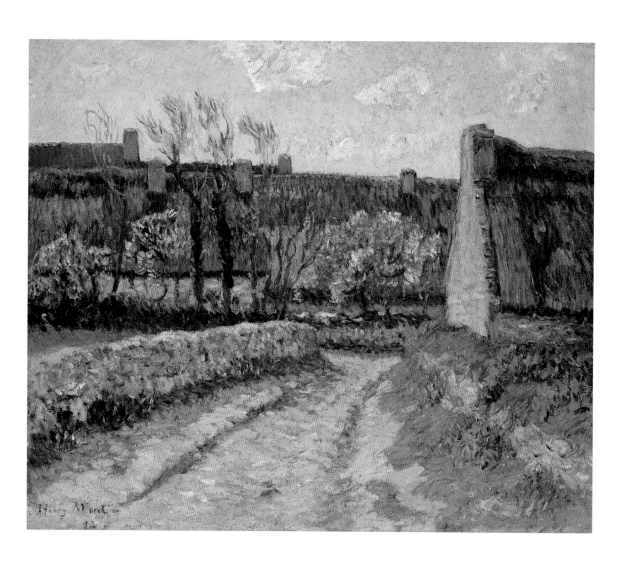

Berthe Morisot (1841–1895)

At Bougival

c. 1881, unsigned and undated | Oil on canvas, 59.6 x 73 cm | NMW A 2491
Purchased by Margaret Davies from an unknown source, before 1939

Morisot initially trained with Corot, who introduced her to *plein air* painting, but after meeting Edouard Manet while she was copying Old Masters in the Louvre she came increasingly under his influence. Both she and Manet came from wealthy bourgeois Parisian families. In 1874 she exhibited at the first Impressionist exhibition and at the age of 33 married Manet's younger brother Eugène, a man of wealth, leisure and good taste who could support her career. Their daughter Julie was born in 1878 and from this period onwards her work, possibly due to the influence of Renoir, becomes more confident, looser in execution and larger in scale.

In 1880, she and her husband began to spend time at Bougival, ten miles west of Paris on the Seine. They rented a house at 4, rue de la Princesse in 1881 for four years and visited there regularly. The attractive gardens appear in a number of Morisot's charming domestic paintings of the period such as *Eugène Manet with His Daughter at Bougival* (1881 Musée Marmottan, Paris, *page 108*) and *Child in the Rose Garden, Bougival* (1881 Walfaff Richartz Museum, Cologne). Julie Manet is a favourite subject for her mother at this time and this freely painted picture shows her and her nanny Paisie in the more informal garden of a neighbour, Dr Robin. Julie, now three years old, is shown standing in a russet-coloured hat and a brown dress offering something, perhaps a flower, to the seated Paisie. The tall plants and foliage surrounding them are summarised speedily with brushstrokes that are ciphers for the forms they illustrate. The picture has a dazzling sunlit quality. It was painted without a ground onto the back of a primed canvas, so the bright brown tones of the composition are often due to the artist leaving the canvas unpainted. The relationship

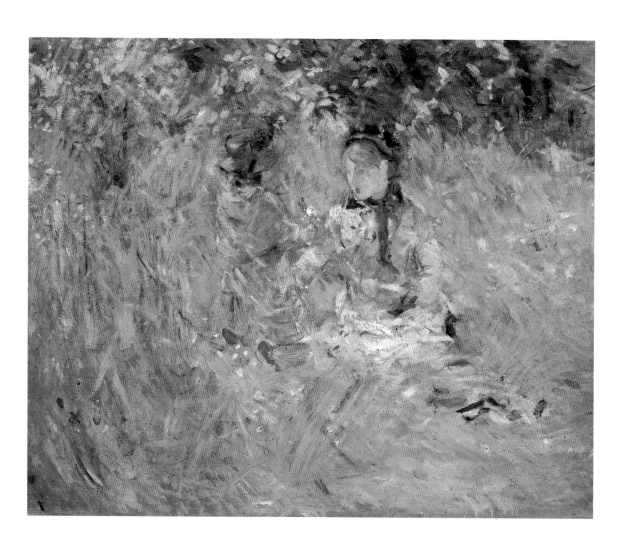

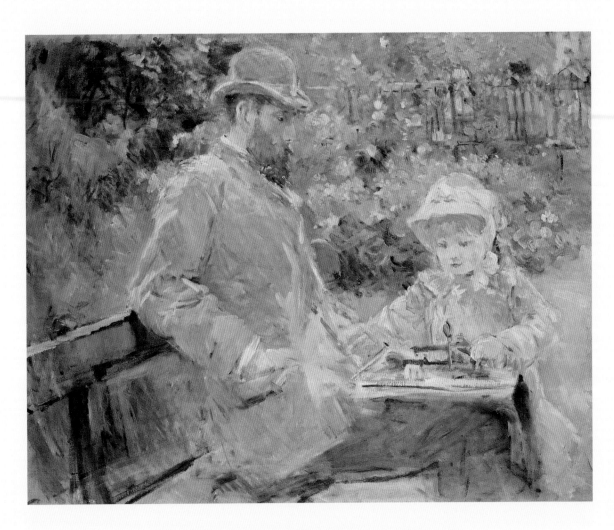

Berthe Morisot (1841-1895), *Eugène Manet with his Daughter at Bougival* c.1881
Oil on canvas, Musée Marmottan, Paris, France/www.bridgeman.co.uk

between Julie and Paisie is explored in other works painted at Bougival such as *On the Balcony of Eugène Manet at Bougival* 1881 (private collection) and *The Tale* 1883 (private collection). In other works of the same period, such as *The Sand Castle* 1882 (private collection), Julie is seen wearing the same distinctive chestnut hat.

Morisot continued to paint under her maiden name and exhibited this work along with eleven others at the seventh Impressionist exhibition in 1882, although it is not mentioned in the hand-written catalogue, which was produced in a much more amateurish way than the previous catalogues. The arrangement of their hanging was supervised by her husband Eugène, as she was in Nice attending to the young Julie. He kept her constantly informed about developments over the hanging of the show. On 1 March he wrote 'As soon as I got back to Paris I went directly to the Salle des Panoramas. I found all the scintillating group of Impressionists hanging pictures in an enormous hall. Everybody was delighted to see me, especially as I had come for the purpose of arranging your works.' He updated her on 6 March, 'Don't be upset because the papers don't mention you, the problem is that you are not to be seen at the exhibition, whilst your colleagues make great efforts to be around'. He describes the present work as 'Bibi and Paisie' and details the ordering of a white and gold frame for it, and that the asking price was 1,200 francs. He ends his letter by explaining that his brother 'Edouard, who came to the exhibition this morning, says that your pictures are among the best'. This was a compliment indeed, as 210 works were displayed altogether, amongst them Renoir's *Luncheon of the Boating Party* (1881, Phillips Collection, Washington). This picture, and others of similar domestic subjects, illustrate that whilst Morisot was accepted as an equal in the Impressionist exhibitions, her life still chiefly revolved around her home and domestic circumstances.

It is not known exactly when or where Margaret Davies purchased this painting. Bernheim-Jeune sold it to John Nevill of the Stratford Gallery in 1912 and it is then next recorded on loan to Aberystwyth in 1945. It hung at Gregynog in Margaret's bedroom and is thought to have been there before 1939, suggesting that it was a personal favourite.

Camille Pissarro (1831–1903)
Sunset, Port of Rouen, Smoke

1898, signed and dated 'C. Pissarro. 98' | **Oil on canvas 65 x 81 cm** | **NMW A 2492**
Purchased by Margaret Davies from the Leicester Galleries, London in 1920

Camille Pissarro came from a wealthy family of Portuguese-Jewish descent, who lived in the West Indies, where he was born. He was sent to France for his education and trained initially with Corot. He met Monet at the Académie Suisse where he enrolled in 1855. He was more politically motivated than other Impressionists, having anarchist sympathies. He was also the oldest of the group, being two years Manet's senior and thus he commanded a certain respect amongst the Impressionists. Like Monet he went into exile during the Franco-Prussian War in London and he returned to take a prominent lead in the arrangements for the first Impressionist exhibition. It was while he was in London that he had admired Turner's paintings and saw Claude's harbourside views in the National Gallery. In this work, painted nearly thirty years after his first visit to London, he returns to both Turner and Claude for inspiration, specifically in the way he depicts the scene looking directly into the setting sun, showing the influence of the former. The standing figures on the quayside, silhouetted against the setting sun with their long shadows, are a common device in the seaport scenes of the latter. Pissarro certainly knew that the two artists' works were juxtaposed on display at the National Gallery because, in a letter of 1902, he recommended his son Lucien to go and view them.

Pissarro first worked in Rouen in 1883 and in 1884 he moved from the outskirts of Paris to the village of Eragny about thirty miles east of Rouen, borrowing funds from Monet to purchase his house. By the 1890s he was, like Monet, pursuing 'series' paintings, particularly of Paris, Rouen, Dieppe and Le Havre. Also like Monet he experienced difficulties with his eyesight, suffering from

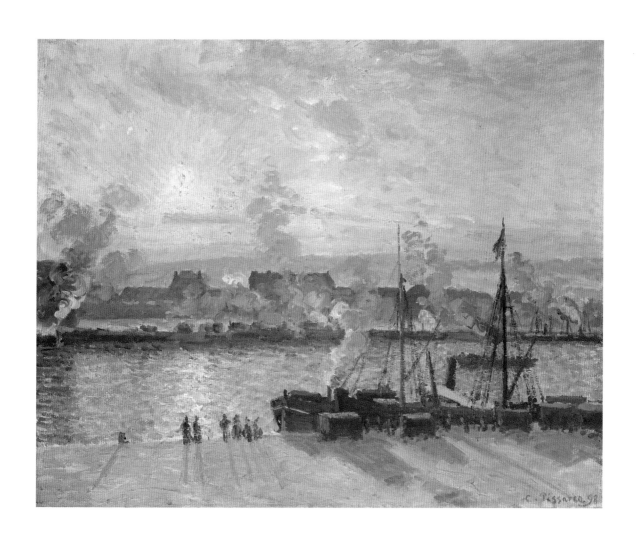

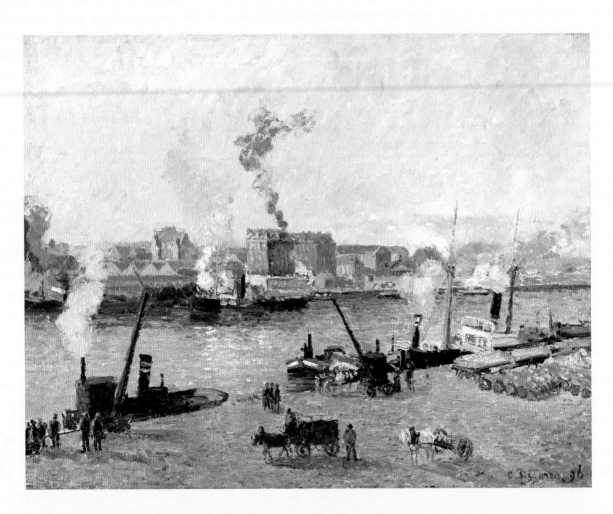

Camille Pissarro (1831-1903), *Misty Morning, Rouen* 1896
Oil on canvas, Hunterian Art Gallery, University of Glasgow, Scotland/www.bridgeman.co.uk

1889 with an infection of the tear duct which made it difficult for him to paint *en plein air* in case of exposure to windy conditions. He therefore painted this work and many of his late series paintings from the windows of hotels, thus giving himself a high viewpoint looking down on the scene below. This particular picture was probably painted from a room in the Hotel d'Angleterre, Cours Boildieu, Rouen, where Pissarro first stayed in 1896. He also stayed at the Hotel de Paris, 51, quai de Paris. From both these hotels he had views of the loading and unloading of ships, the traffic on the bridges over the Seine and the quayside activity. The bustling port, warehouses and factories symbolised the industrial expansion and success of Rouen at the time. In a letter of 1896 to Lucien, Pissarro records his attempts to capture in paint the 'movement, the life, the atmosphere of the harbour thronged with smoking ships, bridges, chimneys, sections of the city in the fog and mist, under the setting sun etc.' This atmospheric painting with its rich sunset colours in the sky and reflections in the river is one of a group of fourteen works painted in 1896 and 1898. He takes the view looking upstream from the Hotel d'Angleterre, with warehouses just visible in the smoke that appear in numerous other paintings as well, such as *Misty Morning, Rouen* (1896 Hunterian Art Gallery, University of Glasgow, *left*). This view and that of the Pont Boildieu, which was visible in the opposite direction on the Seine from the hotel, were the two principal motifs of his 1896 and 1898 Rouen paintings (*The Boildieu Bridge at Sunset in Misty Weather*, 1896, Musée d'Orsay or *Boildieu Bridge, Rouen, Sunset*, 1896, Birmingham Museum & Art Gallery). The Pont Boildieu group of paintings includes a chimney to the left which is omitted from the other group. In this painting the smoke on the left edge blowing across the view probably belches forth from this chimney, concealing it completely. Pissarro appears to have conceived the works in response to the criticism of a Symbolist critic Gabriel Mourey who promoted literary and fantastic subjects. 'I've got a motif that will make poor Mourey despair' he wrote 'imagine from my window, the new quarter of Saint-Sever, straight across, with the frightful Gare d'Orléans all new and shiny, and a lot of striking chimneys, big and small. On the first plane, boats and water, left of the station the working-class quarter which runs along the quay to the iron bridge, the Pont Boildieu; it's morning, with the sun and mist. That imbecile Mourey is a brute to think that it's banal and down-to-earth. It's as beautiful as Venice'.

Margaret Davies purchased this picture in 1920, possibly for sentimental reasons, for during the First World War she had worked there for the Red Cross. Initially she and her sister Gwendoline had worked together at a Red Cross centre at Troyes, but in 1917 Margaret had moved on to work on her own in Rouen.

Camille Pissarro (1831-1903)

Pont-Neuf, Snow Effect, 2nd Series

1902, signed 'C.Pissarro. 1902' | Oil canvas: 54.5 x 65.3 cm | NMW A 2493
Purchased by Margaret Davies from the Leicester Galleries, London in 1920

Between 1900 and his death in 1903, Pissarro intermittently rented rooms at 28, place Dauphine, one of the old houses on the north side of the Ile de la Cité, and during this period he produced fourteen views of the Pont-Neuf at various times of day and of the year. He finished the first series in 1901, and this work is from the second series. As with the previous painting of the harbour at Rouen, Pissarro's Paris series were all painted from the windows of hotels, looking down on to walkways and thoroughfares, and in so doing emphasising his remoteness from the teeming bridge below. His vantage point resulted in a plunging perspective which accentuated the steep roof-tops in the buildings and the stoutness of the massive piers of the bridge. While from one window in his apartment he looked northward and painted the Pont-Neuf, from another he had a view north-west overlooking the Square du Vert-Galant, and he painted a series of this view simultaneously. The two groups of paintings are quite distinct and separate - in the Pont-Neuf series the bridge is not viewed attached to the island, and in the Square du Vert-Galant works the terrace of the square is only once faintly attached to the Pont-Neuf. The Pont-Neuf series of paintings is reminiscent of the Pont Boildieu, Rouen paintings.

Like Manet before him (*page 77*), in this example, painted in his seventieth year, Pissarro captured Paris in the winter snow. However, whereas Manet as a younger man in the National Guard depicts the still silence of snow with no sign of human life during one of the darkest moments in the history of Paris, Pissarro captures the capital as a modern urban metropolis but still under a grey snow-laden sky. There is a motor car, carriages, pedestrians with umbrellas and delicate street lamps poised on the massive architecture of the bridge, which joins the Ile de la Cité to the right bank of the Seine. The Pont-Neuf is one of the oldest, most historically important thoroughfares in the city. The milling crowd is less dense here, however, than in some of the other paintings, perhaps because the snow deterred pedestrians and vehicles.

Initially, however, Pissarro intended a very different subject for this canvas. *Pont-Neuf* is painted onto the unprimed reverse of a canvas showing an earlier worked-up still-life on the primed side (*below*). The paint is applied directly to the canvas and where this is left uncovered the brown tone of the canvas gives warmth to the mid-tones of the composition. In other pictures in the series shipping is depicted on the river, which may perhaps have frozen in the winter, and smoke can be seen bellowing from the chimneys of the houses on the Samaritaine with flags flying on their roofs. The snowy sky possibly conceals such details in this view. When Margaret Davies purchased this picture from the Leicester Galleries in 1920, she selected it over a view of the *Pont-Neuf, Rain Effect* dated 1903 (Christie's 4 Dec 1973).

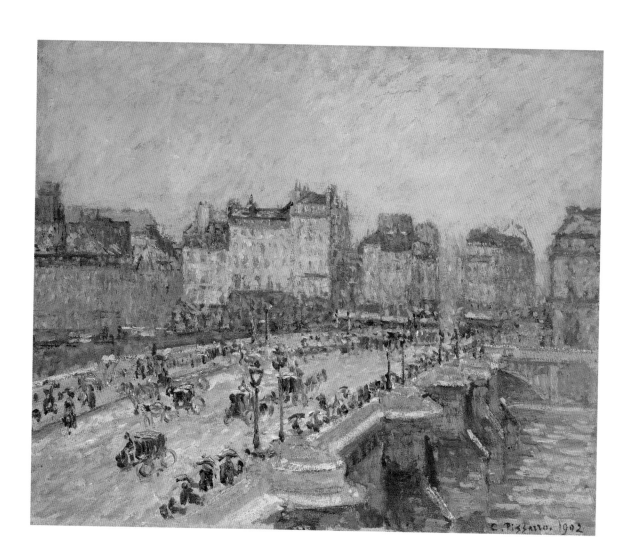

Camille Pissarro (1831–1903)

Peasant Girl

c. 1890, undated | Signed with initials in black chalk, recto, bottom right: C.P. | black chalk on blue grey wove paper, 39.2 x 31 cm | NMW A 1696 | Purchased by Margaret Davies from the Leicester Galleries, London in June 1920

Pissarro concentrated increasingly on drawing during the late 1870s and 1880s, focusing especially on life drawing. Drawing was both a means to practise and develop his dexterity, and a source of income through the sale of finished pastels and gouache fans.

As a politically committed artist, who engaged with anarchism and socialism, Pissarro had a sociological concern to depict peasants realistically in everyday settings and activities. In the context of the nineteenth-century migration of rural dwellers to the cities, his depictions of peasants at the market place can be seen as the rural equivalent of the urban cafe scenes of his fellow Impressionists, and are as much about contemporary life as Degas' laundresses and ballet girls.

Pissarro's sketches for scenes of peasants working in fields were often made on the spot then developed in the studio using posed models. The preparatory process appears to have been a slow one, with Pissarro exploring the shapes of the figures he wanted to assemble in the finished composition. He seems to have created a stock of figure studies to which he could return for numerous pictures. The date of this work has been debated by scholars but the drawing is close to a figure in a gouache, *The Market*, of around 1883. In the gouache the figure occupies the centre of the composition, at close range, facing another woman, with the bustle of the market in the background. The pose of *Peasant Girl* also loosely corresponds to a coloured etching, made later on in 1894–5, *A Market Scene* (Ashmolean Museum, Oxford, *right*).

The *Peasant Girl*'s rounded form, the curve of her shoulder, the crook of her elbow, the barely observed clumsy shoes - possibly clogs - peeping out from under her skirts, are reminiscent of Millet's monumental peasant figures. She is drawn in black chalk, Pissarro's favoured drawing material, which seems to have given him a broad vocabulary of marks, from the loose rendering of her sleeve to the deliberate delineation of the thumb of her hand at her waist, the pleats in her cap, and her snub nose and plump cheek.

JC

Camille Pissarro (1831-1903), *A Market Scene* 1894-5, Black crayon with pen and black ink, grey wash and white body colour on tracing paper laid down on stiff white paper. Ashmolean Museum, Oxford

Camille Pissarro (1831-1903)
Two Girls

c. 1890, undated and unsigned | black chalk and khaki chalk on pink laid paper, 48 x 62.2 cm | NMW A 1697
Purchased by Margaret Davies from the Leicester Galleries, London in June 1920

'I do a session in the sun each morning; the rest of the day I work on gouaches and my figure paintings'.
(Pissarro to his son Lucien in July 1887)

Pissarro struggled to make a living from his art: during the Franco-Prussian war he lost large numbers of his oil paintings when his home at Louveciennes was taken over in his absence by the Prussians.

There was an increased interest in drawings in France during the 1870s and the Impressionists submitted works on paper to their shows, in particular the fourth and final ones in 1879 and 1886. Pissarro submitted twelve fans and four pastels along with his twenty-two oils to the 1879 show, which was the first Impressionist show to make a profit.

Pissarro produced more works on paper during the late 1870s and 1880s, including sketches as part of his preparatory process, and he seems to have learnt a lot from Degas when the two practised printmaking together in 1879. Like Degas, he focused on the human figure in his drawings. Pissarro used a variety of papers, sketching on blue and pink sheets later on in his career, although the velvety khaki pastel highlights in *Two Girls* are quite unusual as Pissarro favoured black chalk for sketching. The two figures appear to have been used in the painting *Peasants Chatting in a Farmyard, Eragny* of 1895-1902. They also appear in a gouache, *Two Women in a Garden* of 1888, now in the Metropolitan Museum, New York, so if the date of the drawing is correct these figures could have been adapted from this latter work.

The figures are explored more thoroughly than in *Peasant Girl* (*page 117*), with the folds and tie of the apron of the figure on the right being more detailed. In the figure on the left Pissarro has captured the attitude of someone engaged in conversation, listening intently, even though the details of her face are sparse. These studies reveal Pissarro's process of developing ideas constantly as he worked, so that he could recycle an idea pursued previously, perhaps using a model in the studio to explore the pose in detail, which he could then develop into a new composition.

JC

Camille Pissarro (1831-1903), *Two Women in a Garden* 1888, Gouache on silk. Framing lines in graphite. The Metropolitan Museum of Art, Bequest of Grégoire Tarnopol, 1979, and Gift of Alexander Tarnopol, 1980. Photograph © 1999 The Metropolitan Museum of Art

Pierre-Auguste Renoir (1841–1919)

La Parisienne

1874, signed and dated 'A Renoir. 74' | **Oil on canvas, 163.5 x 108.5 cm** | **NMW A 2495** | **Purchased by Gwendoline Davies from the National Portrait Society's exhibition at the Grosvenor Gallery, London in March 1913**

La Parisienne is the most famous painting in the National Museum of Wales's collection and is popularly known as 'The Blue Lady'. Renoir's painting shows a young woman with deep brown eyes, wearing blue, who glides across the picture plane effortlessly as she puts on her gloves. Features such as a doorway at upper left side and a curtain at the upper right have been subsequently painted out by the artist, so that the figure seems to float in a general space. The picture was called *La Parisienne* when it was first shown but the work acquired its popular title early on. When exhibited in Paris in 1892 it was called *La Dame en Bleu*. The painting was one of six oils and a pastel Renoir contributed to the first Impressionist exhibition in 1874 (*page 14*). Most of the critics mentioned *La Parisienne* in passing and while Chesneau regarded it as a 'failure', *Le Rappel*'s Jean Prouvaire warmed to it and gave it his own personal interpretation: 'The toe of her ankle boot is almost invisible, and peeps out like a little black mouse. Her hat is tilted over one ear and is daringly coquettish. Her dress does not reveal enough of her body. There is nothing more annoying than locked doors. Is the painting a portrait? It is to be feared so. The smile is false, and the face is a strong mixture of the old and the childish. But there is still something naive about her. One gets the impression that this little lady is trying hard to look chaste. The dress which is extremely well painted, is a heavenly blue'.

The model who inspired the artist and the critic was the young actress Henriette Henriot (1857-1944) who at just sixteen years old had recently returned to Paris from a tour of the provinces. Her origins were humble, and she later went to extreme lengths to conceal them. She was the daughter of a milliner, herself illegitimate, and her name was

Georges Numa, Portrait of Henriette Henriot
Bibliotheque nationale de France

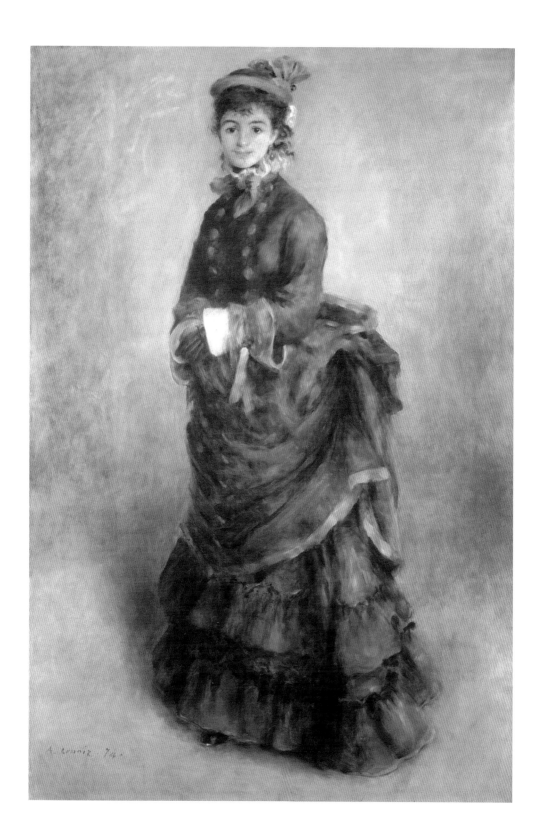

Pierre-Auguste Renoir (1841-1919), *Madame Henriot* c.1876
Oil on canvas, Gift of the Adele R. Levy Fund Inc., Image © 2005 Board of Trustees, National Gallery of Art, Washington

an assumed theatrical one. Although she went on to play parts at the Odéon and starred in André Antoine's productions at the Théatre-Libre, in 1874 she was just a young, unknown girl waiting to make her mark in Paris. She sat frequently for Renoir in the 1870s, appearing in at least eleven of his paintings. In other works she is shown in theatrical costume: as *The Page*, (1875-6 Columbus Museum of Art, Ohio), as a nymph in *La Source*, (1875 Barnes Foundation) and as herself in the beautiful portrait of around 1876 (National Gallery of Art, Washington, *left*), the only picture of herself by Renoir she ever actually owned. In fact, contemporary photographs reveal that this dark-eyed actress was not particularly beautiful, and that Renoir's pictures flattered her. Eventually however, Henriot felt frustrated by her own career and lived out much of her ambition through her only illegitimate daughter Jane, who tragically died aged just twenty-one in a theatre fire. Henriot never married, and she retired in 1900 following her daughter's death. She maintained contact with Renoir though, and he painted a touching portrait of her in old age one last time in 1916.

The first owner of *La Parisienne* was Stanislas-Henri Rouart (1833-1912), an accomplished artist himself who contributed to the first Impressionist exhibition (*page 15*). He was also an enterprising industrialist and an astute collector of contemporary French art. He paid Renoir 1,500 francs for this picture in 1874, hanging it in his house at the rue de Lisbonne along with Renoir's *Riding in the Bois de Boulogne*, 1873 (Hamburger Kunstalle, Hamburg) and works by Cézanne, Degas, Manet, Monet, Morisot, Pissarro and Sisley. His remarkable collection was visited regularly by artists including Paul Signac, who in 1898 described the picture as 'a large portrait of a woman in blue painted by Renoir in 1874. The dress is blue, a pure intense blue. The contrast makes the woman's skin look yellowish and the reflection makes it look green. The interaction between the colours is captured admirably. It is simple, fresh and beautiful. It was painted twenty years ago, but you would think it had come straight from the studio.'

The warm cream-coloured oil ground plays a significant role in the final appearance of the painting, as the overlying paint is either thin, as in the background, or loosely brushed. The areas of hair against the hat and above the earring, as well as the earring itself and the upper eyelashes, appear to have been added over the varnish layer.

Interestingly, Signac does not mention the name of the model, who was by this time one of André Antoine's regular leading ladies, routinely offered 'tous les rôles de cocottes'. Rouart's collection was broken up after he died and it was auctioned in Paris in December 1912. *La Parisienne* was jointly purchased by Knoedler and Durand-Ruel. The latter sold his share to the former and the work was displayed at the National Portrait Society exhibition in London at the Grosvenor Gallery, where it was purchased by Gwendoline Davies. She immediately sent it to the Holburne of Menstrie Museum in Bath, where the Davies sisters' collection was on loan and where it was eagerly awaited.

Pierre-Auguste Renoir (1841–1919)

Young Girl in Blue

c. 1883, signed lower right 'Renoir' (in pen and ink?) | Oil on canvas, 54.7 x 35.6 cm | NMW A 2496
Purchased by Margaret Davies from the Claude Roger Marx sale in Paris in March 1914

By the time Renoir made this sketch he had achieved a degree of financial success as a result of the dealer Durand-Ruel purchasing his paintings in considerable numbers and his success with portraiture. It was also a period of reflection for him, and of new important influences. He was beginning to feel uneasy with the sketchiness of Impressionism and was inclined to turn to the art of the past for inspiration. At the end of 1881 he departed for Italy: 'I have suddenly become a traveller and I am in a fever to see the Raphaels ... I have started in the north and I am going to go to the toe of the boot'. He visited Venice, Padua, Florence, Rome and Naples where he studied the paintings from Pompeii. He returned to Paris via Marseille and in January 1882 was staying at L'Estaque and working with Cézanne. However, he went down with pneumonia and was seriously ill. On his doctor's advice he travelled to Algeria, and although he only intended to stay there for two weeks, he ended up staying for over six, immersing himself in the bright light and the colours. These were conventional routes for nineteenth-century artists, especially one like Renoir, who was beginning to acknowledge the influence of Ingres and Delacroix.

During the early 1880s then, Renoir became increasingly interested in the linear tradition in French art. He was already studying Ingres before he went to Italy and he began painting in translucent veils of colour over a densely primed white ground around 1880 - a method that needs great sureness of handling since it does not allow overpainting. The more defined treatment of form is reflected in this unfinished sketch on board primed with white lead paint producing a cool, light tonality. In 1883, Renoir had a one-man exhibition at Durand-Ruel's gallery, with seventy works on view. In his introduction to the catalogue,

Théodore Duret wrote 'I regard M Claude Monet as the Impressionist group's most typical landscape painter, and M. Renoir as its most typical figure painter'. It has been suggested that the model in this sketch is the same girl used in Renoir's famous *The Umbrellas* (National Gallery, London, *below*), a work in which Renoir demonstrated his new concern with line, form and eighteenth-century elegance with complete mastery. Painted initially around 1881, Renoir returned to that work in 1885-6, painting by this time with far greater precision and crispness.

This small sketch was owned by the critic Claude Roger Marx (1859-1913), who wrote a book on Renoir's lithographs.

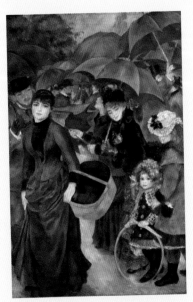

Pierre-Auguste Renoir (1841-1919)
The Umbrellas 1881-6, Oil on canvas
© National Gallery, London

Pierre-Auguste Renoir (1841–1919)

Conversation

1912, signed 'Renoir' | Oil on canvas, 54.2 x 65.2 cm | NMW A 2494
Purchased by Gwendoline Davies from the Bernheim-Jeune Gallery, Paris in December 1917

This work dates from the last decade of Renoir's life, when he was suffering from acute arthritis. A frail figure, his hands were crippled and his brushes had to be tied to them to enable him to paint, but unlike some of the other Impressionists his vision remained sharp. He acknowledged that he could 'only paint broadly' now and he wrote in 1918 'I'm struggling with my figures, to make them one with the landscape which acts as their background, and I want people to feel that neither my figures nor my trees are flat'. The colour schemes in his later paintings are also much warmer, dominated by pink and orange as here, and Titian and Rubens were his greatest influences as well as Delacroix. In the year that he painted this work he moved to an apartment in Nice because his rheumatism was so bad but in June he suffered an attack of paralysis. During a visit to Paris he was treated by a Viennese doctor, but he was forced to realise that he would not walk again, and from then on he was confined to a wheelchair. Despite his difficulties, he was still painting and had also taken up sculpture.

In this work, probably begun in the grounds of his summer house at Essoyes in Burgundy and finished later in Nice, Renoir shows a young couple deep in thought and contemplation. Gwendoline Davies purchased the work as *Jeune Homme et Jeune Femme Assis* and quite how it acquired its present title of *Conversation* is unclear, since the couple are clearly not conversing and the young woman looks particularly quiet and contemplative, staring downwards, while her companion appears to glance over at her in a subdued fashion.

Auguste Rodin (1840–1917)

Saint John the Baptist

c. 1880, undated | signed 'A Rodin' | bronze, 206 x 54 cm | NMW A 2497
Purchased by Margaret Davies from the Georges Petit Gallery, Paris in April 1917

Despite his reputation today and undoubted dominance of the last quarter of the nineteenth and early twentieth centuries, Auguste Rodin was not initially a successful sculptor. He was born in Paris in 1840, and after being rejected by the prestigious Ecole des Beaux-Arts in Paris three times he entered the studio of sculptor Albert-Ernest Carrier-Belleuse (1824-1887) in 1864. In order to support himself during this barren early period, Rodin created decorative portrait busts to earn a living. As a result, in spring 1876 he was able to travel to Italy where he encountered original works by Michelangelo (1475-1564) and Donatello (1386-1466), which had a resounding impact on the sculptor's work.

Rodin entered competitions throughout Europe before he finally began to gain recognition as a sculptor, and even then fame was accompanied by a certain amount of controversy. So lifelike and unforgiving were Rodin's sculptures that critics and experts speculated over whether the works were actually casts of the human form. Although these claims may seem ridiculous now, they illustrate how revolutionary Rodin's work was. The sculpture around which this controversy first centred was entitled *The Age of Bronze*, a male nude exhibited at the 1877 *Salon*; this work had first been shown under the title *The Vanquished* in Brussels earlier that year.

Rodin responded to his critics by creating the slightly larger than life-size *Saint John the Baptist*, executed in plaster in 1880 when the sculptor was forty-one. The realistic and faithful nature of Rodin's modelling is demonstrated in this work, which depicts a naked striding figure. It relates closely to the *Striding Man* (1877-1900), although the focus in the latter work is the movement of the body, with the arms and head

absent. Saint John the Baptist was a popular subject with Renaissance sculptors, and their work, particularly that of Donatello, provided Rodin with the inspiration. Unusually, Rodin shows the figure of the Saint naked, with none of his common attributes. Although clearly in the action of moving forward, Saint John has both feet planted firmly on the base - neither foot is bent and the weight is spread equally, recalling ancient Egyptian and Archaic Greek sculptures.

Rodin chose his models according to personality; of the model for this work he commented 'there was a knock at the door of my studio. It was an Italian ... I immediately thought of John the Baptist ... a man of nature, a visionary, a believer, a precursor come to announce someone greater than himself'. There is some controversy over the identity of the model, however, as two known Italians modelled for Rodin at the time of Saint John's creation - César Pignatelli and Danielli. It may be that Saint John is actually an amalgamation of the two figures.

LB

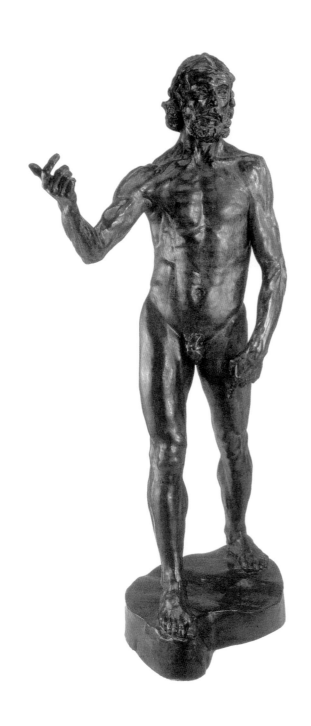

Auguste Rodin (1840–1917)

Eve

c. 1881/1890s, undated | signed 'A Rodin' | bronze, 173 x 56 x 65cm | NMW A 2498
Purchased by Gwendoline Davies from The French Gallery, London in July 1916

Rodin was a prolific sculptor who, despite his troubled start, received numerous commissions. The largest sculptural project he embarked on was entitled *The Gates of Hell*, a commission he received in 1880 for the new Musée des Arts Décoratifs. A complicated mass of figures, the prototype for *The Gates* was provided by Lorenzo Ghiberti's (1378-1455) doors to the Baptistery in Florence, created in the fifteenth century. Rodin also took inspiration from Dante Alighieri's text *The Inferno*, and the central figure of *The Thinker* can be read as both a portrait of Dante contemplating the writhing forms below, and the power of man's creative mind. *The Gates of Hell* was inspired by Michelangelo's *Last Judgement* from the east wall of the Sistine Chapel.

Rodin created two large-scale, freestanding figures that he envisaged would form part of *The Gates of Hell*, *Adam* and *Eve*. Both works were inspired by scenes from Michelangelo's Sistine Chapel ceiling. Rodin's Eve is shown naked, in the act of being expelled from the Garden of Eden, in an almost identical pose to Michelangelo's Eve (*right*). Her head is hidden in disgrace and she embraces her breasts, one palm faces outwards in the gesture Adam adopts in Michelangelo's work; Rodin conflates the two poses.

The model who sat for this work was pregnant at the time of the sitting. Rodin was unaware of her condition, discovering the pregnancy only halfway through the modelling, and he recalled how he had had to alter the area of her pelvis daily without realising why. Rather than being displeased with this revelation, Rodin was delighted; it hadn't occurred to him to employ a pregnant model, but he felt this 'aided the character of the figure singularly'. *Eve* remains unfinished, however, as the model eventually found the studio too cold and stopped visiting the sculptor. There

is some debate as to who the model for Eve was. It has long been accepted that she was Anna Abruzzezzi, however it has recently been suggested that Abruzzezzi was too young as she was only born in 1874, and that Carmen Visconti was the model. However, as the date of the creation of the large-scale bronze is not absolutely certain (it may have actually been modelled as late as the 1890s), it is possible that, although she did not sit for the small work, Abruzzezzi was the model for this *Eve*.

Eve was first created in plaster and later cast in bronze. It was exhibited publicly in Paris originally in the Salon of 1899. There were two different versions of the bronze; the second version is termed *Eve and the Rock*, owing to the large form at the back of Eve's legs that was included in the marble in order to provide support.

LB

Michelangelo, *The Fall and Expulsion from Paradise*
The Sistine Chapel © 2003 Vatican Museums. Direzione dei Musei

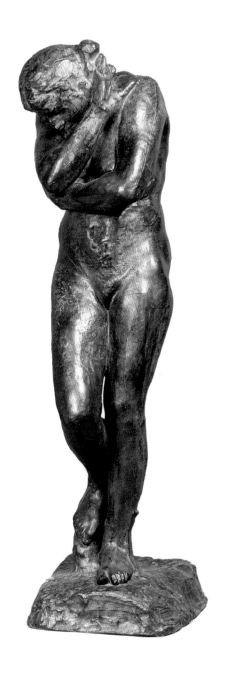

Auguste Rodin (1840–1917)

The Kiss

c. 1887, undated | signed 'A Rodin' | bronze, 182.9 x 112 x 112 cm | NMW A 2499
Purchased by Gwendoline Davies from Georges Petit Gallery, Paris in September 1912

One of Rodin's most iconic works is *The Kiss*. As is true of many of Rodin's sculptures, several editions of the work exist altogether and, as with the majority of his work, there are both bronze and marble versions. *The Kiss* is another work conceived as part of the large commission *The Gates of Hell*, a project that dominated Rodin's work from the date of its commission in 1880.

The two entwined figures are Paolo Malatesta and Francesca da Rimini, a couple by whom Rodin was fascinated and whom he depicted in several works. Paolo and Francesca lived in Italy in the thirteenth century and were immortalised by Dante in *The Inferno*. Paolo was Francesca's brother-in-law, who had been entrusted with her safety by his brother, her husband. They fell in love after reading about the passion of Lancelot and Guinevere from the Arthurian Legend, but on their first kiss were caught and murdered by Giancotto Malatesta, Francesca's jealous husband. Their illicit love condemned Paolo and Francesca to eternal damnation in the second circle of Hell. Rodin poignantly portrays the lovers at the point at which their fate is sealed, and locks them in an eternal kiss. The volume of Arthurian Legends is visible in Paolo's left hand. Rodin captures the immediacy of the lovers' passion through the unusual dispersal of weight in the composition of this work. It is Francesca who seems in control as she pulls Paolo towards her; Paolo in contrast rests one hand lightly on Francesca's thigh, while the other clutches the book. The reference to the lovers is oblique; the naked figures bear no obvious reference to the famous couple and there is no allusion to the tragedy of their situation - the couple are depicted in the state of ecstasy. Interestingly, although both figures are nude neither have genitals, Rodin has rendered the lovers unable to consummate their forbidden love.

This work, although originally intended for *The Gates of Hell* (it appears on several early studies for the work), was removed from it in 1886. Rodin felt the subject matter was incongruous with the essence of the Gates; the couple were depicted in the state of pure happiness surrounded by tortured, writhing souls. There are several versions of *The Kiss*; the first was created in 1882, a bronze half the size of this work. Rodin was commissioned by the French State in 1887 to create a version in marble which was slightly larger than life; this was not finished until 1898. A second marble was carved, which is now in the Tate. The bronze edition to which this work belongs was cast by Alexis Rudier, who became Rodin's founder in 1902.

In addition to being one of his most iconic, this is also one of Rodin's most influential sculptures. Artists such as Constantin Brancusi (1876-1957) (*below*) and Raymond Duchamp-Villon (1876-1918) created works directly influenced by *The Kiss*.

LB

Constantin Brancusi (1876-1957), *The Kiss* 1923-5, Limestone, Paris Musée National d'Art Moderne – Centre Georges Pompidou, © Photo CNAC/MNAM Dist. RMN/© Philippe Migeat

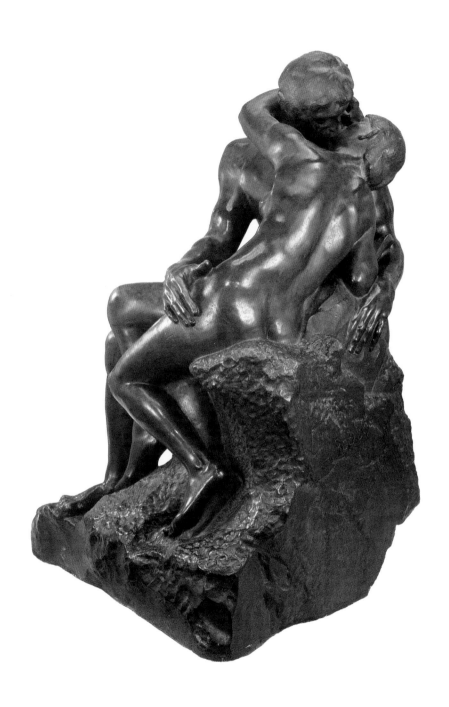

Auguste Rodin (1840-1917)

Head of Whistler's Muse

c. 1904, cast later in 1984 | signed 'A Rodin, No 4/8' | bronze, 35 x 26 x 20 cm | NMW 143
Purchased by the National Museum of Wales from Bruton Gallery Ltd, Somerset in April 1989

In 1903 Rodin was commissioned to create *Project for a Monument to Whistler*. He accepted no fee for it, only expenses. This was a commission from the English committee for the International Society of Sculptors, Painters and Gravers, headed by James Pennell. Whistler, who had died in 1903, was the Society's first President; Rodin was his successor. Unusually, Rodin did not produce a posthumous portrait of Whistler but created 'a heroic figure of fame, or the triumph of art and one man over the artlessness of the world' in the form of a nude female figure. The work was to be sited on the Chelsea Embankment in London and in Lowell, Massachusetts, where Whistler was born.

Rodin chose Gwen John (1876-1939) as his model, a Welsh artist who was living in Paris at this time and who had been taught by Whistler. It was during the creation of *Project for a Monument to Whistler* that Gwen John and Rodin became lovers. However, Rodin was by no means exclusively John's lover and, although he had several other mistresses at this time, she became obsessed with him. This work is essentially a portrait of John and her image appears in several known studies for the *Project*; in addition to the finished plaster there are two large plasters, a small maquette and three studies of the head. *Head of Whistler's Muse* varies in all seven versions - in some the eyes or mouth are open, in others they are closed.

The monument suffered numerous delays and Rodin wrote to the committee several times reporting that it was not quite finished. On the sculptor's decision to show the work at the 1908 *Salon*, the committee requested an image which was sent with an explanation that the work now represented a Muse, rather than Victory and, although the work was currently without arms, he intended to show her with a medallion on which Whistler's portrait would be visible.

However, later that year Rodin's studio was flooded by the Seine and the plaster was damaged; the work was further delayed. Unfortunately, the sculpture was incomplete at the time of Rodin's death and his estate offered the committee a marble version in lieu of the bronze. The work was viewed by, amongst others, Gwen John's brother and fellow artist Augustus, and they reported that it was 'a poor thing', unworthy of both Rodin and Whistler.

Augustus John recalled in 1952, '[Gwen] used to pose for Rodin, for she had, he said, "un corps admirable"... Rodin produced a colossal figure for which my sister posed ... This was rejected ... I came upon it, neglected in a shed, in the grounds of the ... Musée Rodin. In the Master's house at Meudon numerous other studies of my sister have recently been discovered...'.

This is a modern cast from the plaster head in the Musée Rodin in Paris.

LB

Jean Francois Limet, Photograph
of *Whistler's Muse* in Rodin's
Studio, Musée Rodin, Paris

Auguste Rodin (1840-1917)

The Earth and Moon

c. 1899, undated | signed 'A Rodin' | marble, 120 x 68.5 x 63.5 cm | NMW A 2509
Purchased by Gwendoline Davies from The French Gallery, London in July 1914

The Earth and Moon is one of only two marble sculptures by Rodin purchased by the Davies sisters. Rodin rarely carved marble sculptures himself, as he disliked working the stone. As soon as he could afford to he employed *praticiens* or studio assistants, such as Emile Antoine Bourdelle (1861-1929) and Constantin Brancusi, to work up the marble from the plaster original. His *praticiens* were often well-known sculptors who worked under his strict instruction; he had a thorough understanding of the stone and remained in complete control of the process.

This work, like *The Kiss* and *Eve*, derives from the large commission *The Gates of Hell*. Although the museum building for which the work was intended was never built and the sculpture remained unfinished at the time of Rodin's death, it provided the nexus for much of his most important work from the 1880s onwards. *The Earth and Moon* illustrates the influence of Michelangelo's unfinished *Captives* (Academia, Florence) on Rodin. Although the visual effect of the two artists' work is similar, their intentions are markedly different; Michelangelo refers to freeing the forms from within the stone yet the works remain unfinished. Conversely, Rodin's sculptures are very much finished, yet clearly derived from the natural world.

In *The Earth and the Moon*, two figures, one male, one female, emerge highly polished from the stone, contrasting with the rough-cut marble. An acquaintance of Rodin referred to his marble sculptures as 'thought emerging from matter' and there is a direct contrast between untamed nature, represented by the stone, and cultured man, represented by the emerging figures. The figures appear small against the large block of raw marble, serving as a reminder of man's humanity. The title of this work also calls to mind the mundane and the ethereal.

One of Rodin's contemporaries remarked 'You will not find monsters in the Hell of Rodin ... the evil demons through whom these men and women suffer are their own passions, their loves and hatreds; they are their own flesh, their own thoughts'.

LB

Auguste Rodin (1840-1917), *The Gates of Hell*,
Bronze, Musée Rodin, Paris

Armand Seguin (1869-1903)

Breton Peasant Women at Mass

c. 1894 (not signed or dated) | Oil on canvas, 55.5 x 38.5 | NMW A 2500
Purchased by Gwendoline Davies from Mrs Hilda Thornton of Sion Hill, Bath in July 1916

Born in Brittany and trained in Paris, Seguin died young at the age of 34 of tuberculosis. He was a skilled and inventive printmaker and his oil paintings are relatively rare. Seguin initially adopted a Pointillist style but then joined the circle of artists working at Pont-Aven in 1891. He probably met Gauguin in 1894 on the eve of his departure for Tahiti, and he saw him again after his return. Seguin was much influenced by both Gauguin and Émile Bernard and the group of artists who called themselves 'Nabis', from the Hebrew word for Prophet. Like Gauguin, Seguin employs flat areas of strong colour to convey the simplistic devotion of the Breton peasant women at worship. However, his style is much more graphic than that of Gauguin, reflecting his interest in printmaking, and his drawing is more mannered, as in the depiction of the elongated thin fingers here. Gauguin appears to have viewed Seguin as a follower and wrote a preface to his *Le Parc de Boutteville* exhibition in the spring of 1895. In this he wrote 'Seguin, above all else, is a thinker:- by which I certainly do not mean that he is a literary artist; – he does not paint just what he sees, but what comes from his thoughts, and this he does through an innovative harmony of lines'.

In this intimate portrayal of religious devotion, Seguin focuses on the serious concentration on the faces of the women, with their downcast eyes and hands on their prayer books. He does not concern himself with an exact definition of space, such as whether these women are standing or kneeling. The work is thinly painted on a hessian canvas with a commercially prepared oil ground and is typical of the Nabis style at this time. Gwendoline Davies purchased the present painting, not surprisingly believing it to be by Gauguin, from Hilda Thornton of Bath, who was the widow of the artist Alfred Thornton. The latter had met Gauguin whilst he was painting in Brittany in 1890 and 1891, but appears to have purchased this picture later, probably at the Carfax Gallery in London. The painting was loaned two years after the Davies sisters purchased it, along with Cézanne's *Midday, L'Estaque* and *Provençal Landscape* (*pages 45 and 49*) to the Victoria Art Gallery exhibition in Bath of 1918-20. The curator John Witcombe wrote in April 1918 to Gwendoline Davies: 'The Cézannes ... and the Gauguin we, who have seen and thought much, consider the finest pictures in the Gallery - even though we have seven Gainsboroughs. But the former artists have an element of austerity which our great English portraitist lacks'. Alfred Thornton noted that this painting was 'aesthetically considered, the finest picture here'. The work was re-attributed to Seguin in 1960 shortly before the death of Margaret Davies and first exhibited as by Seguin in 1966.

Paul Signac (1863-1935)

St Tropez

1918, signed and dated with the title in pencil, recto, bottom right, P. Signac / St. Tropez 1918 | watercolour, charcoal and pencil, 27.1 x 40.7 cm | NMW A 1710 | Purchased by Gwendoline Davies form the Eldar Gallery, London in February 1920

Signac was the same age as Pissarro's oldest son Lucien, and the two sketched together. Signac had met Pissarro in 1885 and had introduced him to Seurat. At the age of 16, he had attended the 1879 Impressionist show and, moved by the paintings of Monet, had begun to pursue an art career of his own. Erudite and articulate, he produced the manifesto for Pointillism, *D'Eugène Delacroix au Neo-impressionisme* in 1899, and wrote on Jongkind, who had influenced Monet early in that artist's career. Pertinently for the National Museum of Wales, he also wrote eloquently on Renoir's use of colour in *La Parisienne (page 123)*.

With Seurat, whom he met in 1884, he developed Impressionism into Pointillism, which would influence Pissarro during the 1880s. The Impressionists' method of laying down strokes or flicks of unmixed paint side by side developed, through research into Delacroix's colour theory, into Seurat's scientific approach, where hues were analysed and quantified for specific effects and applied in dots and flicks.

Signac and Seurat exhibited in the final Impressionist show of 1886. Like Pissarro, Signac was politically engaged, having an interest in anarchism. His sociological approach to the industrial landscape included the depiction of gasworks. He painted St Tropez during the First World War, when he became a pacifist. He had first visited the town when it was a small fishing port in 1892, and during the 1890s had divided his time between Paris and St Tropez.

Around this time, encouraged by Pissarro, he had begun to paint in watercolours: the medium suited him far better than oil for painting quickly outdoors. His watercolours are much freer than the schematic systematizing of his oils, and by the early 1900s he was producing them as finished works in themselves. This 1918 watercolour uses the Pointillist colour theory of modelling shadow with complementary colours, in the violet and yellow undulations of watercolour emulating watery ripples. The ripples of the water and the masts of the boats, loosely drawn in black chalk, have a calligraphic quality strongly reminiscent of the simple elegance of the Japanese prints that had long influenced the Impressionists.

His first watercolours had employed heavy ink drawings with minimal washes of colour, whereas the later works are lightly drawn with black chalk before adding colour.

Like his friend Pissarro, Signac's career links older and younger generations of avant-garde artists: the young Matisse stayed with Signac at St Tropez in 1904 and demonstrated his interest in Pointillist colour theory in his *Luxe, calme et volupté* in 1905, a work which Signac owned.

JC

Alfred Sisley (1839-1899)

Moret-sur-Loing (Rue de Fosses)

1892, signed 'Sisley. 92' in blue paint, lower left corner. | Oil on canvas, 38.5 x 46.9 cm | NMW A 2502
Purchased by Margaret Davies from the O'Hana Gallery, London in 1960

Sisley is renowned for his paintings of the Seine and of Paris, but he continually renewed his art and, like the other Impressionists, later found inspiration away from the capital. He turned his back on the Seine-side suburbs downstream from Paris and instead looked to the Forest of Fontainebleau for new subjects, where he had not worked since the 1860s. In 1880, with his partner Eugénie Lescouezec and their children he settled in the small village of Veneux-Nadon near Moret-sur-Loing, a few miles south of Fontainebleau and some two hours train journey from Paris.

In 1888 they moved into the town of Moret-sur-Loing itself. The picturesque houses and squares, the Gothic church, the River Loing and surrounding countryside provided Sisley with inspiration for the last decade of his career. He lived there until the end of his life and wrote of the place 'at Moret my art has undoubtedly developed most ... I will never really leave this little place that is so picturesque'. And indeed apart from an extended visit to England and Wales in 1897, he remained there. By 1891 Sisley and his family had settled at 19, rue de Montmartre where he set up a studio in his attic and tended the garden. According to visitors, the house was full of the artist's unsold paintings, for he did not enjoy the popularity of some Impressionist artists such as Monet. Increasingly, he became somewhat isolated at Moret, having to refuse invitations to the Impressionist events due to his declining health and the expense of travelling and staying in Paris.

In the summer of 1892 Sisley painted a number of views of the streets near his home, and he produced this small, charming view of the curving rue des Fosses, which once formed the old walled boundary of Moret, that autumn. Sisley positioned himself in the forecourt of the old school (now destroyed) to paint this view. He subtly evokes the autumnal atmosphere with varied touches of warm, pure colour describing the different textures of the trees in the foreground, the smooth wall surfaces of the houses and the tiles on the roofs. He uses pink and red in abundance. A gate has been casually left open, revealing an adult and child in a secluded courtyard, while a tram passes on the street. *Village Street, Moret-sur-Loing* (Glasgow City Council Museums, *below*) possibly dates from the same period, and probably shows the adjacent square Place de Samois.

Sisley nursed the terminally ill Eugénie at their home in Moret, following their late marriage in Wales. He completed the Welsh views back in his studio, and he died in 1899 and was buried in the cemetery at Moret. The Davies sisters were not drawn to his art when they started collecting, despite Hugh Blaker recommending him. Margaret Davies purchased this work just two years before her death in 1960.

Alfred Sisley (1839-1899), *Village Street, Moret- sur-Loing* c.1894
Oil on canvas, Glasgow City Council (Museums)

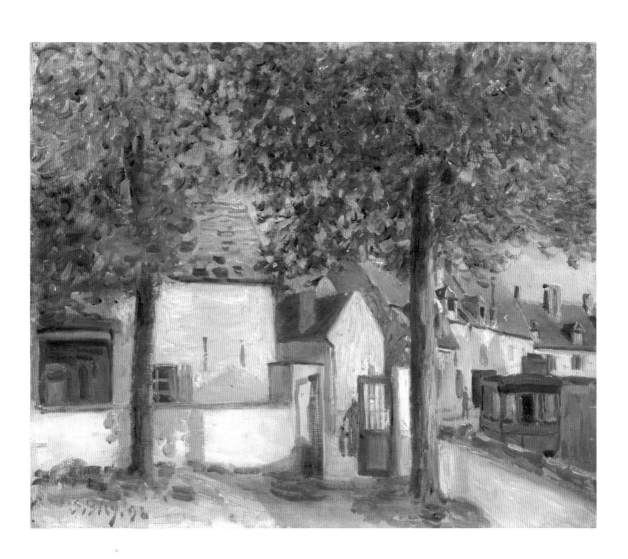

Alfred Sisley (1839–1899)
The Cliff at Penarth, evening, low tide

1897, signed and dated lower left, 'Sisley '97' | Oil on canvas, 54.4 x 65.7 cm | NMW A 2695 | Purchased by the National Museum of Wales from Sothebys with assistance from the National Art Collections Fund and the Gibbs Family Trust in November 1993

Sisley was a committed Impressionist landscape painter, adhering to the tenet of direct painting from nature until the end of his life. He was also the only Impressionist to paint the Welsh landscape, visiting south Wales in the summer of 1897 while his health was declining. The nineteen paintings he produced of Penarth and of Langland Bay near Swansea are his only seascapes. They are all painted on French canvases he brought with him. At the age of 57, on the breezy cliffs outside Penarth, he admitted the practical difficulties of painting *en plein air*, 'against the wind which reigns supreme here. I have not experienced this before'. Although born in Paris, his parents were English and he retained British nationality throughout his life. His father ran a successful import business for luxury goods. Sisley was fluent in English and had worked in London from 1857 to 1860, studying commerce. By the time he returned to England in 1874 his career path had changed and he was a young ambitious artist who had just exhibited six paintings at the first Impressionist exhibition in Paris. On that occasion he found inspiration at Hampton Court and East Mosley on the Thames. He experienced a frustrating visit to the Isle of Wight in 1881, when his canvases failed to reach him from France. In 1897, after the failure of a large retrospective exhibition in Paris, which was a major disappointment, Sisley arrived in Wales having been encouraged by his loyal patron François Depeaux, a Rouen businessman with contacts in south Wales. Sisley decided to take up the challenge of new locations and the result of his extended stay was a group of astonishingly vibrant responses to the Welsh coastline.

He travelled with his partner Eugénie. They initially visited Falmouth but, after failing to find inspiration there, moved

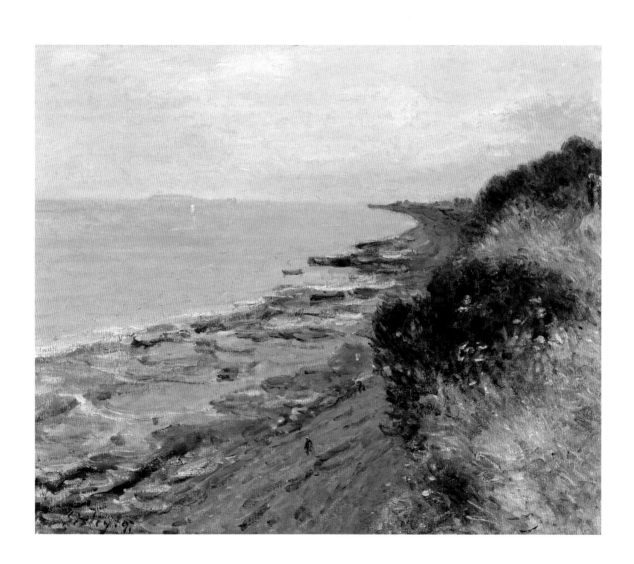

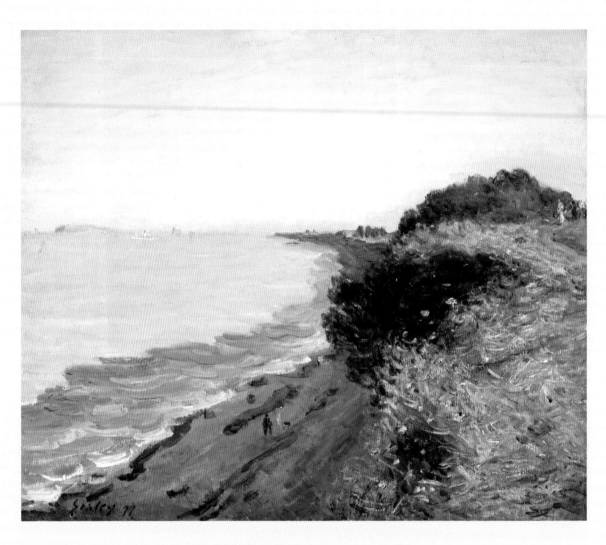

Alfred Sisley (1839-1899), *Bristol Channel, Evening* 1897
Oil on canvas, Allen Memorial Art Museum, Oberlin College, Ohio; Gift of Norbert Schimmell, 1952

on to the 'coal mining town' of Cardiff. By July 9 1897 they were settled in lodgings with Mrs Thomas at 4, Clive Place, Penarth. He soon found a spot on the cliff-top walk from Penarth to Lavernock with an excellent view of the Bristol Channel and its busy shipping lane of vessels serving the Cardiff Docks. Sisley described the view as 'superb' and was fascinated by the unique geological structure of the cliffs and the spectacular tidal fall of the Bristol Channel. In this painting he captures the evening light raking sharply from the west, creating a mauvish shadow from the steep cliff on to the beach below – the island of Steep Holm is just visible in the middle distance. It is interesting to compare it with the *Bristol Channel, Evening* (Allen Memorial Art Museum, Oberlin College, Ohio, *left*), which appears to be an earlier evening view and also has figures on the cliff and beach. A coloured crayon sketch in the Musée du Petit Palais, Paris is inscribed 'le Canal de Bristol (effet de soir)' and could be a study for either of these works. There were two periods of low tide while Sisley was staying in Penarth, 21-25 July and 5-8 August. It is likely these works were painted during late July, because by the later date Sisley was busy with other matters. He and Eugénie, now aged 62 and also in poor health, finally married at Cardiff Town Hall on 5 August. They had lived together for over thirty years and Sisley had endured financial hardship as a result of his father's disapproval of Eugénie's social status – she was a humble florist when they met – and now they wished to secure their children's inheritance, away from France where it was generally assumed they were already married. By 15 August they had left Mrs Thomas's house for the more exclusive Osborne Hotel at Langland Bay and were enjoying their honeymoon. While staying on the Gower, Sisley worked

energetically, producing a series of observations of light and sea, cliffs, beaches and the bathing machines on them. It seems likely that he finished his Welsh views back in Moret after consulting the numerous drawings and notes he had made while in Penarth and at Langland Bay.

Alfred Sisley (1839–1899)

Storr Rock, Lady's Cove – the evening

1897, signed and dated lower left, 'Sisley, 97' | Oil on canvas, 65.5 x 81.5 cm | NMWA 26362 | Purchased by the National Museum of Wales from Sothebys with assistance from the National Art Collections Fund in June 2004

Sisley and Eugénie enjoyed their honeymoon at the Osborne Hotel (now demolished), Langland Bay on the Gower. The artist did not have to venture far for inspiration. On 18 August he wrote 'I have been here for 5 days. The countryside is totally different from Penarth, hillier and on a larger scale. The sea is superb and the subjects are interesting.' They appear to have been visited by his patron Depeaux while they were there – a pencil sketch of the lounge of the Osborne Hotel survives which is inscribed by the artist 'to Monsieur Depeaux, a memento of his visit to the Osborne Hotel. His obedient A. Sisley' (private collection). Sisley's works on the Gower divide into two groups. The first are views along the beach at Lady's Cove (now Rotherslade Bay), an inlet at one end of the larger, popular seaside destination Langland Bay, which the hotel overlooked, showing the beach itself and surrounding cliffs. He worked in oil and pastel, making a number of drawings capturing the bathers with their bathing huts and visitors walking along the cliff paths with the shimmering seas below. The second group of paintings concentrates on Storr Rock (known popularly locally as 'The Donkey Rock'), taking this landmark as the principle motif. He was fascinated by this enormous isolated outcrop of steeply dipping, well bedded carboniferous limestone, which was situated only a few yards from below the Osborne Hotel's gardens. A near contemporary photograph illustrates the inlet at the end of Langland Bay as it appeared at the time of their visit, when the Osborne Hotel was at the height of its popularity. From this and following exploration of the site, it is clear that Sisley probably painted this view from the wooden Victorian structure above the beach itself. Five paintings of the rock are known including this one. For

Alfred Sisley (1839-1899), *Storr's Rock in Langland Bay* 1897
Oil on canvas, Kunstmuseum Bern

Alfred Sisley (1839-1899), *Lady's Cove, Wales* 1897, Oil on canvas, Bridgestone Museum of Art, Ishibashi Foundation, Tokyo

some of these he was clearly located on the coastal footpath and he observed the rock at different times of day and tide in the September sunshine, as in *Lady's Cove, Wales* (Bridgestone Museum of Art, Tokyo, *left*).

In the present work, a bravura piece, the geological outcrop is shown at low tide, concentrating on the north face of the rock. In the foreground a small boy wearing a sailor suit regards the vast rock above him, reminding us that it was no doubt, as it is now, a favourite haunt of young children. The beach is partly in shadow with the evening light producing purplish tinges in the rock, while on the horizon small sailing boats are just visible. *The Wave - Langland Bay* (private collection) and *Storr's Rock in Langland Bay* (Kunstmuseum, Berne, *page 148*) are the same size as this work and are painted from the beach area, which at that period included a wooden pavilion. Both show the tide further in, although in the former this is much more obvious with a wave dramatically crashing on to the rock while the latter is much closer to the present depiction. It is probable therefore that these two works, showing the rock in morning and evening, were to be read as a pair. There are two smaller canvases (Musée des Beaux-Arts at Rouen and the Bridgestone Museum, Tokyo), painted from a viewpoint further to the east on the cliff path and showing green field patterns on the headland beyond. The tide has come in, surrounding the rock and isolating it from the coast, crashing once again against its massive form. A breakwater now links the main rock to a series of rocky outcrops, thus slightly distorting Sisley's topography. The local golf club was founded in 1904 and the headland is now dominated by the well-known golf course. Painting at the end of his life and in poor health, Sisley may well have been exploring the theme of endurance in these five paintings of the rock, which remains stable and unchanged. The inclusion of the young child in this particular work however might illustrate wistfulness for his own youth. These Welsh seascapes might well have been inspired by Monet's paintings of the sea at Fécamp, which were exhibited at the seventh Impressionist exhibition.

The Sisleys' stay at the Osborne Hotel also recalls a nostalgic era when that part of the Gower was particularly exclusive, boasting a number of fine hotels in the area, which enjoyed good train links. Today, all those hotels have closed and although the area is still renowned for its stunning scenery, camp sites and holiday homes dominate the tourist trade. Sisley and his wife returned to Moret at the end of September, and in early October the artist concluded that the visit had been a success, having brought back twelve paintings. He continued to work on them and two were acquired by Depeaux. Monet also heard that he was trying to sell the works, but six were in the sale held after his death to raise funds for his children, and his daughter Jeanne owned *The Wave* until 1909 and *Langland Bay - the morning* until 1919, suggesting that commercially he enjoyed nothing like the success of Monet's series pictures.

Maurice Utrillo (1883–1955)

Montmartre

c. 1914, undated | Signed in blue chalk, recto, bottom left, Maurice Utrillo V | watercolour and gouache on board, 27.7 x 37.4 cm | NMW A 1797 | Bequeathed to the National Museum of Wales by Dr F. H. K. Green in 1978

Utrillo's mother was Suzanne Valadon, a model who had been encouraged by artists including Degas to become an artist in her own right. It was Valadon who encouraged the young Utrillo to start painting as a diversion from the alcoholism that plagued his life and led to several bouts in sanatoriums. The name Utrillo was given to him by a family friend, the Spanish critic Miguel Utrillo y Molins. In spite of the chaotic nature of his life he was prolific, producing thousands of oils, gouaches, watercolours and pencil sketches.

Almost wholly self-taught, Utrillo's approach seems to have been instinctive, often drawing from memory or copying photographs and postcards. His work shares spontaneity with the Impressionists, although he seems less interested in light effects and his scenes are devoid of narrative content, political or otherwise. Rather, they have a flatness that can be interpreted as alienation. His works usually depict street scenes, mostly his native Montmartre, and are characterised by wide roads sharply receding, with tall verticals of shuttered houses and shops, often with the text on the building fronts copied out, sometimes with the addition of naively sketched figures.

This gouache is probably from his Colourist Period, which began after 1914. The gaiety of Montmartre, with its pretty houses and brightly coloured shutters and its landmark ice-cream domes of Sacré-Coeur, is undercut by the isolation of the lone figures in the distance. The cropped lanterns of Sacré-Coeur betray the probable postcard source of the image and heighten the jaded sense of the scene. It is signed Maurice Utrillo V. in honour of Suzanne his mother, a signature Utrillo adopted from 1910.

From 1909 Utrillo exhibited at the *Salon d'Automne* and in 1912 he exhibited with Picasso, Derain, Cézanne, Braque, Delaunay and Matisse. He had a successful career, and in 1929 the French Republic awarded him the Cross of the Legion of Honour.

JC

James Abbott McNeill Whistler (1834–1903)

St Mark's Venice: Nocturne in Blue and Gold

c. 1879-80 | Oil on canvas, 44.5 x 59.7 cm | NMW A 210
Purchased by Gwendoline Davies from an unknown source in January 1912

Whistler was an American artist who received his training in Paris in the studio of Gleyre. He was a friend of Fantin-Latour, Legros and Courbet. He exhibited at the *Salon de Refusés* in 1863 and in 1864 sat with Manet, Baudelaire and others for Fantin-Latour's *Homage to Delacroix (page 66)*. He also exhibited at the Royal Academy in London and his first one-man show was held in London in 1874. In 1877 he was involved in the famous court case with John Ruskin, when he sued the art critic over criticism of his picture *Nocturne in Black and Gold: the Falling Rocket*. Although he won the case, he was awarded only a farthing in damages without costs and consequently was declared bankrupt the following year. In 1879 the Fine Art Society paid for him to visit Venice to work on a series of etchings. He wrote from Venice that he was especially fascinated by the evening light, when this 'amazing city of palaces becomes really a fairy land'. While there he also painted about thirteen oil paintings but only this picture, another nocturne entitled *Nocturne in Blue and Silver: the Lagoon, Venice* (Museum of Fine Arts, Boston) and a sketch of a girl (private collection) are known. Otto Bacher, a contemporary artist in Venice at the same time, described his technique for painting his nocturne pictures: 'Night after night he watched ... without making a stroke with brush or pen. Then he would return to his rooms and paint the scene, or as much of it as he could remember, going again and again to refresh some particular impression'. Whistler was painting in the tradition of J. M. W. Turner, who had also painted a moonlit view of the Piazza San Marco entitled *Juliet and her Nurse* (private collection). His atmospheric *Nocturne Palace* series of etchings also owe a debt to Turner.

James Abbott McNeil Whistler (1834-1903), *Nocturne in Blue and Silver: The Lagoon, Venice* 1879-80
Oil on canvas, Museum of Fine Arts, Boston, Emily L. Ainsley Fund, 42.302, Photograph © 2005 Museum of Fine Arts, Boston

In this work, Whistler's viewpoint is taken from the north side of the Piazza San Marco on the way down the Procuratie Vecchie. He shows the Renaissance Torre del' Orologio to the left, although no details of the astronomical clock or the famous pair of Moors who strike the bell are visible in the dark. The facade of St Mark's, which was built between 1063 and 1094, is somewhat abruptly cut off at the right and the essential elements of the architecture become more prominent in the darkness. This most famous landmark was undergoing extensive renovation at the time of Whistler's visit and scaffolding may be visible on the left. The building is silhouetted against a blue-black sky, the rich ornamentation, mosaics and famous bronze horses are all lost in the darkness of the night. While the buildings look dark, empty and cavernous, the spots of creamy light are the recently installed gas lamps. Whistler's technique is much more traditional than Monet's impasto technique in his Venetian paintings (*pages 99, 101 and 103*). Whistler employs a dark, pinky ground and his brushstrokes are smooth, flat and blended. When this work was later exhibited in 1886-7 at the Society of British Artists during the year of Whistler's presidency, he commented 'I think it is the best of my nocturnes'. It seems probable that the Davies sisters were drawn to this work because of their fondness for viewing Venice at night time. Margaret Davies wrote in her diary on the eve of their departure from Venice on 27 April 1909 'It is a lovely starlight night, many like ourselves take advantage of it to wander up and down in their gondolas. We pass by the Piazza, giving a last look at St Mark's, the little lamps, on the facade which faces us, before the mosaic of the Madonna, are burning brightly, as they do each night'.

Bibliography

General Reading

Adler, Kathleen, *Impressionism* (National Gallery Publications Limited, London 1999)

Denvir, Bernard, *The Chronicle of Impressionism, An Intimate Diary of the lives and World of the Great Artists* (Thames & Hudson Ltd, London 1993)

Evans, Mark and Fairclough, Oliver, *The National Museum of Wales, A Companion Guide to the National Art Gallery* (National Museum of Wales in association with Lund Humphries Publishers 1993)

Frascina, Francis, et al, *Modernity and Modernism, French Painting in the Nineteenth Century* (Yale University Press, New Haven & London 1993)

Herbert, James D., *Fauve Painting, The Making of Cultural Politics* (Yale University Press, New Haven and London 1992)

Herbert, Robert L., *Impressionism, Art, Leisure and Parisian Society* (Yale University Press, New Haven and London 1988)

House, John, *Impressionism Paint and Politics* (Yale University Press, New Haven and London 2004)

Hughes, Peter, *French Art from the Davies Bequest* (National Museum of Wales, Cardiff 1982)

Ingamells, John, *The Davies Collection of French Art* (University Press, Oxford 1967)

Madeline, Laurence, *100 Impressionist Masterpieces*, Paris 1999 (èditions Scala, Paris 1999)

Pool, Phoebe, *Impressionism* (Thames and Hudson, London 1967)

Rewald, John, *The History of Impressionism* (Museum of Modern Art, New York, 1946, rpt, Secker and Warburg, London, 1980)

Thomson, Belinda, *Impressionism, Origins, Practice, Reception* (Thames & Hudson Limited, London 2000)

White, Eirene, *The Ladies of Gregynog* (University of Wales Press, Cardiff 1985)

Books

Brettell, Richard, and Lloyd, Christopher, *Catalogue of Drawings by Pissarro in the Ashmolean Museum*, (Oxford University Press, Oxford 1980)

Daulte, François, *Alfred Sisley* (Editions Durand-Ruel 1959)

Gaunt, William, *Renoir* (Phaidon Press Limited, London 1962)

Gere, Charlotte and Vaizey, Marina, *Great Women Collectors* (Philip Wilson Publishers, London 1999)

Hamel, Mary Michele, Doctoral Thesis *A French Artist: Léon Lhermitte* (1844-1925), (University of Washington, Louisiana, 1974) would you like this here or under Other Sources?

Lloyd, Christopher, *Camille Pissarro* (Skira, London 1981)

O'Byrne, Robert, *Hugh Lane 1875-1915* (The Lilliput Press, Dublin 2000)

Pissarro, Joachim, *Monet's Cathedral Rouen* 1892 - 1894 (Pavilion, 1990)

Shone, Richard, *Sisley* (Phaidon Press Limited, London 1992)

Smith, Paul, *Interpreting Cezanne* (Tate Publishing, London 1996)

Watkins, Nicholas, *Bonnard* (Phaidon Press Limited, London, 1994)

Werner, Alfred and Rewald, Sabine, *Utrillo* (Thames and Hudson, London 1918)

Exhibition Catalogues

Alfred Sisley, Royal Academy of Arts, London, 3 July 1992 - 18 October 1992 (touring)

Art in the Making - Impressionism, The National Gallery, London, 28 November 1990 - 21 April 1991

Berthe Morisot 1841-1895, Palais Des Beaux-Arts, Lille, 10 March 2002 - 9 June 2002

Bonnard, Tate Gallery, London, 12 February 1998 - 17 May 1998 (touring)

Boudin & Jongkind, An Exhibition of Paintings, Watercolours and Drawings, Noortman & Brod Limited, Holland, 12 November 1983 - 17 December 1983 (touring)

Camille Pissarro, Impressionism, Landscape and Rural Labour, City Museum and Art Gallery, Birmingham, 8 March 1990 - 22 April 1990 (touring)

Cézanne Watercolours, Pasadena Art Museum, Pasadena, 1967

Degas: Beyond Impressionism, National Gallery, London, 1996

Degas Images of Women, Tate Gallery Liverpool, 1990

Degas's Complete Sculpture, Alan Wofsy Fine Arts, San Francisco, 1990

Fantin-Latour, National Gallery of Canada National Museums of Canada, Ottawa, 1983

Impressionist Drawings, Ashmolean Museum, Oxford, 1986 (touring)

Impressionism and the North: Late 19th Century French Avant-Garde Art and the Art in the Nordic Countries 1870-1920, Nationalmuseum, Stockholm, 25 September 2002 - 25 May 2003

Impression, Painting Quickly in France, 1860-1890, Sterling and Francine Clark Art Institute Williamstown, Massachusetts, 16 June 2001 - 9 September 2001

Impressions of Venice from Turner to Monet, National Museum of Wales, Cardiff 1992

Louis Eugène Boudin, Precursor of Impressionism, Santa Barbara Museum of Art, California, 8 October 1976 - 21 November 1976 (touring)

Manet: The Still Life Paintings, American Federation of Arts and the Réunion des Musée Nationaux/Musée d'Orsay, Paris, 9 October 2000 - 7 January 2001 (touring)

Monet in London, High Museum of Art, Atlanta, Georgia, 9 October 1988 - 8 January 1989

Monet in the 20th Century, Museum of Fine Arts, Boston, 20 September 1998 - 27 December 1998

Monet in the '90s, The Series Paintings, Museum of Fine Arts, Boston, 1989

Monet, Late Paintings of Giverny from the Musée Marmottan, New Orleans Museum of Art, New Orleans, 7 January 1995 - 12 March 1995 (touring)

Monet, Renoir and the Impressionist Landscape, National Gallery of Ireland, Ireland, 22 January 2002 - 14 April 2002

Paul Cezanne: The Bathers, Öffentliche Kunstammlung Basel 1989

Paul Signac, Marlborough Fine Arts, London, 1986

Pissarro, Museum of Fine Arts, Boston, 1980

Pissarro: son art - son oeuvre, Alan Wofsy Fine Arts, San Francisco, 1989 (?)

Post-Impressionism, Cross-Currents in European Painting, Royal Academy of Arts, London, 17 November 1979 - 16 March 1980

Renoir, Hayward Gallery, London, 30 January 1985 - 21 April 1985 (touring)

Renoir's Portraits, Impressions of an Age, National Gallery of Canada, Ottawa, 27 June 1997 - 14 September 1997 (touring)

Rodin in his Time, The Cantor Gifts to the Los Angeles County Museum of Art, California, 1994

Rodin Sculpture and Drawings, Hayward Gallery, South Bank, London, 1 November 1986 - 25 January 1987

Sisters Select, Works on Paper from the Davies Collection, National Museums & Galleries of Wales, Cardiff, 30 September 2000 - 11 February 2001 (touring)

The Impressionist and the City, Pissarro's Series Paintings, Dallas Museum of Art, Dallas, 15 November 1992 - 31 January 1993 (touring)

The Impressionists at Argenteuil, National Gallery of Art, Washington, 28 May 2000 - 20 August 2000 (touring)

TurnerWhistlerMonet Art Gallery of Ontario, Toronto 12 June - 12 September 2004 (touring)

Vincent van Gogh, Rijksmuseum, Amsterdam, 1990

Watercolour and Pencil Drawings by Cezanne, Laing Art Gallery, Newcastle upon Tyne, 1973

Articles

Evans, Mark, 'The Davies sisters of Llandinam and Impressionism for Wales, 1908-1923' in *Journal of the History of Collections* v. 16 no. 2 2004 p. 219-244

Korn, Madelaine, 'Exhibitions in modern French art and their influence on collectors in Britain 1870-1918: the Davies sisters in context', in *Journal of the History of Collections*, v. 16 no. 2 2004 p. 191-218

Lilley, Edward, 'Manet's "Modernity" and Effet De Neige â Petit-Montrouge' in *Gazette des Beaux-Arts*, September 1991 p. 107-110

Meyrick, Robert, 'Hugh Blaker: doing his bit for the moderns', in *Journal of the History of Collections*, v. 16 no. 2 2004 p. 173-190

Shone, Richard, 'A Welsh Sisley for Wales' in *Burlington Magazine* 1994, 136 p. 763-764